ILLISTRATION

ILLISTRATION

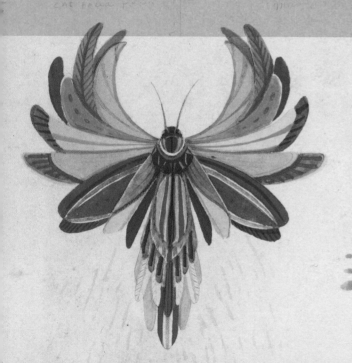

IMPROVISATIONAL LISTS AND DRAWING ASSISTS TO SPARK CREATIVITY

JAIME ZOLLARS

QUARRY

Quarto is the authority on a wide range of topics.

Quarto educates, entertains and enriches the lives of our readers—enthusiasts and lovers of hands-on living.

www.QuartoKnows.com

2016 Quarto Publishing Group USA Inc.

First published in the United States of America in 2016 by

Quarry Books, an impri...
Quarto Publishing Gr...
100 Cum...

Bev...

Library of Congress Ca... ...ata Available.

Cover Design: Laia Albaladejo | Book Des... ...Design, Inc. | Cover Illustrations: Jaime Zollars

Illustrations: All illustrations by Jaime Zollars except pages 97 (flower), 98 101, 142 (cowgirl), 143 (whiskered cowboy), 154 by Julianna Brion; 102 105, 145 (fish), 154 by Calef Brown; 97 (cup and sandwich), 106 109, 142 (sandwich), 145 (face), 148 (sandwich), 154 by Mikey Burton; 96 (cereal), 110 113, 142 (gun), 146 (spaghetti), 154 by John Hendrix; 97 (dragon), 114 117, 155 by Meg Hunt; 97 (octopus), 118 121, 143 (monster hug), 155 by Aya Kakeda; 96 (bee), 122 125, 155 by Roman Muradov; 97 (people), 126 29, 146 (people), 155 by Brian Rea; 97 (shoes), 130 133, 156 by Julia Rothman; 96 (alligator), 134 137, 142 (boots), 143 (teacups), 1 56 by Whitney Sherman; 96 (creature with hose), 97 (heart creature), 138 141, 156 by Wilson Swain.

Printed in China

THIS BOOK IS DEDICATED
TO THE WILLING: TO THOSE
WILLING TO TRY, WILLING
TO PLAY, AND WILLING TO
CHALLENGE THEIR WAYS.

—JZ

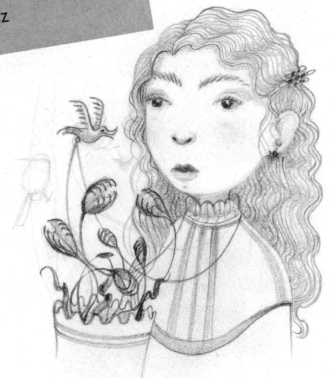

Contents

INTRODUCTION 8

SAMPLE LISTS 18

STARTER LISTS 38

FREE-PLAY LISTS 54

GUEST LISTS 96

NEXT STEPS 142

RESOURCES 153

CONTRIBUTOR BIOS 154

ACKNOWLEDGMENTS 157

ABOUT THE AUTHOR 159

INTRODUCTION

HOW DO CREATIVE PEOPLE COME UP WITH **UNIQUE IDEAS** FOR THEIR WORK?

Welcome dear artists and writers, young and old, those just beginning and those ready to begin again.

You might find yourself here because you are wondering how to summon unique ideas. You may be stuck drawing or writing all of the same things. You may want more from your work, a break from your work, or are finally dedicating yourself to making more work. This book is an adventure for those willing to jump in and explore their own creative range and potential.

When I first started out as a freelance illustrator, I found it took much of my energy to come up with original ideas for stories and paintings. I thought that surely this was the plight of a newbie, and that those people I admired in the creative world were endless wells of award-winning inspiration. I looked forward to the day when ideas would pour out of my head and onto blank pages with ease. Alas, twelve years of creative professional life and six years of teaching at the college level have taught me that inspired ideas are difficult to come by, no matter how long you've been conceiving them. Fortunately, experience has also taught me that if you are open to the unexpected and know where to begin, you will never run out of content and might in fact surprise yourself with what unfolds.

Basics of Improvisation and Applications in Writing and Art

There are many ways to face a blank page. A blank page will not fill itself with inspiration. From where do the images come? Certainly some of my drawings come from a place of rational deduction and careful planning. Others come from real-life experiences and day-to-day musings. But what about when nothing comes out? What about when you are stumped? There are those times when the white of the paper glares back at you and it seems as if anything you do to disrupt its clean, white space feels wrong. Proceeding without rules can feel agoraphobic, akin to swimming in a vast sea of possibility with no land in sight. Complete freedom often stifles creative potential. How can one make something from nothing, especially when anything is possible?

Improv actors make something of nothing all of the time. They are trained to see the potential for something brilliant and surprising and to allow it to unfold each time they take the stage. They learn to generate ideas by playing games! But where do they begin? Improv actors begin with an open mind, an attitude of possibility and positivity, and most importantly, they begin with *rules*. Though it may sound counterintuitive, limiting the possibilities will unlock your most inspired and unique work. Rules allow for focus and will help cultivate specific ideas in lieu of vague, familiar concepts.

Il-LIST-ration is a deceptively simple exercise, which, much like an improv game, offers a challenge and a set of rules to help guide wandering minds. The game begins with a prompt in the form of a list title, which appears on each spread of this book. Use the title as a jumping-off point for creating your own list of characters, places, or things. Your list will spark new and exciting ideas for imagery.

The game may be played over and over, and it will yield new ideas and inspiration every time. This exercise will help put an end to the dilemma of drawing or writing the same things over and over. It will activate ideas that will surprise you and energize your creative side. The results have been known to inspire artists to write imaginative stories, paint unexpected imagery, and create inventive products. Il-LIST-ration will bring out the unpredictable and inspire new work that is fresh and exciting. Use this exercise as a daily warm-up, a weekly recharge, or as a secret weapon in times of need.

LET'S GET STARTED!

Basic Rules of Il-LIST-ration

CHOOSE A LIST

In this book, you will find four primary sections: Sample Lists, Starter Lists, Free-Play Lists, and Guest Lists. Sample Lists are examples of game-play created by me. These lists were made to kick-start your creative thinking. Starter Lists are only halfway complete. They rely on you to fill in the empty lines and sketchbook space with your own interpretations of the ideas offered. Completing these lists provides good practice before tackling lists of your own. The Free-Play Lists are yours to explore. If you have trouble creating your own lists, see the Resources section for tips and ideas. The Guest Lists include both full and half lists so that you may be inspired by and play alongside some of the top illustrators in the field today.

When you are ready to begin, select a list prompt that inspires you. There is a list prompt featured on each spread of this book. Different lists will inspire you at different times, so choose something that motivates you in the moment. This should not feel like a chore, so don't feel compelled to complete the lists in the order they appear. It is a good idea to start with one of the partially completed lists to help kick-start your creativity and embrace the spirit of the game.

WRITE YOUR LIST

Begin responding to the prompt by writing your list. Don't censor your thoughts—you won't have to create them all! Write down whatever comes to mind, even if it doesn't always make sense. The more specific you are in creating your list, the easier and more interesting the creative process will be, so be sure to incorporate compelling adjectives in your answers to make your list unique. Push yourself to include at least ten list items to start, but do keep going if you are so inclined. You are not limited to the number of spaces allotted, so let the ideas flow freely!

RESPOND VISUALLY TO THE LIST

Pick the item from the list that screams the loudest. Which do you really want to create? This is where you start. This initial drawing may lead to another drawing, which may lead to yet another. Follow inspiration wherever it goes. There are no rules once you begin drawing your ideas. When you are ready to move on, select another list item of interest and visualize it until you feel as if you have exhausted all possibilities or have filled the space. Sometimes you'll find yourself illustrating fifteen list items, and other times you may focus on variations of your four favorite entries. You may use your list in any way you like.

REPEAT

Often, a drawing can bring to mind a new item to add to the original list. You may go back and forth between your written list and drawings as much as you like until you feel your exploration is complete!

OPTIONAL

Use the results as inspiration for your next project! You may find wonderful ideas for new projects through this exercise. We'll explore ways to identify and pursue larger projects from your il-list-rations in the last chapter of the book.

Tips and Tricks for Writing Creative Lists

If you find yourself stuck, try using one or more of these techniques. Not all of them will work with all lists, but they provide ways to think through common obstacles that might block your path to productivity.

TAP INTO YOUR INTERESTS

Create a list of things you especially like to draw and mash them up into the prompts. Whether you like to draw organic shapes, panda bears, or high-fashion clothing, you can incorporate these things into the prompts. Combining a fresh concept in a list title with something you already know well is a good way to make exciting new work that still feels authentic to your visual world. These experiments are often the most fruitful, stretching your boundaries without losing your personal vision.

BE SPECIFIC

Add adjectives or brand names to objects and middle names to characters. These details will make the artwork richer when it comes time to start drawing. Any descriptors you are able to add have the potential to make your imagery uniquely yours.

FOCUS ON VARIETY

Variety within each list will help keep the illustration part interesting. List items can be people, creatures, places, or things. Anything is fair game within the prompt. A list titled "Small but Angry" could include deadly insects, screaming babies, and tiny volcanoes. "Band Names Not Taken" could include all genres of music from Heavy Metal to Polka to J-Pop. Practice opening your mind to all of the possibilities available in each list, not just your first thoughts and assumptions.

TRY ALLITERATION

This can be a fun way to add interest to your titles. "Belarus Battleswan" evokes more visual possibilities than a simple "Battleswan," and "Wentley the Weaving Weevil" gives us some fun details to build upon. Simple wordplay is a satisfying way to develop engaging characters and alternative worlds. If your initial word associations are purely based on sound, you can more easily surprise yourself with the visual results.

TRY RHYMING

Just like alliteration, rhyming can create pleasing image names and unpredictable combinations that are enjoyable to draw. If you are stuck, use an online rhyming dictionary for help.

WRITE YOUR LIST FROM A CHARACTER'S POINT OF VIEW

If you are having a hard time coming up with your own list, you may want to explore the list from a specific point of view. This works best on the least descriptive lists. For lists like "Things You'll Never Use," "Rules to Follow," or "Small Annoyances," you may choose to take on a character and write a list from that character's point of view. This is especially useful if you are writing a story about a character and want to get to know that character better. It is also a great way to develop a new character from the ground up. Draw your character alongside its list items.

ADD A RULE TO THE LIST

Contrary to popular belief, this has the potential to make you more creative in your responses. Just like adding a character's point of view in a list, adding a rule to a list can allow you to generate ideas more quickly, simply by focusing your thoughts on something more concrete. You can do this by adding an additional descriptor to the list title. Add the words "in outer space" or "at the North Pole" or "in the wizarding world" after a list title to put a more specific spin on the possibilities, or try adding a specific color or adjective before your list's noun. There are many ways to narrow any given list and to produce some custom-tailored imagery in turn.

Tips and Tricks for Creating Innovative Imagery

DEFINE EACH OF THE WORDS IN THE LIST'S TITLE

Make sure you understand the possibilities for each word in your list entry. Words often have multiple meanings and possible approaches. Using a thesaurus to hash out variations of a word can also trigger creative possibilities. The word "utopian" has synonyms that include "abstract," "fanciful," and "pretentious." These could all lead to different ways of interpreting your response. The word "fragile" could be interpreted as a physical state or a state of mind. By identifying each word's possibilities, you can come up with many inventive options from which to choose.

CONSIDER PEOPLE, PLACES, AND THINGS FOR EACH VISUAL RESPONSE

Even if your prompt assumes a specific category, you may explore others. A list titled "Extravagant Perfumes" could yield elaborate bottles, perfumery shoppe windows, or the people who buy them. You need not limit your drawings to a specific classification.

LIMIT YOUR TOOLS

Less is often more! Sometimes defining a specific set of materials to use for each list can force you to be more creative, opening the doors to new artistic processes. You can choose to bring a list to life using only a ballpoint pen and a highlighter or opt to experiment only with shades of blue and a number two pencil. Self-imposed limitations can actually help you focus and solve problems in innovative ways. The exercises also provide an opportunity to try something new. Try pasting down collage shapes and drawing your solutions on top. Open the gouache you bought ten years ago and pick two colors to work with. Working with different materials will not only keep the process interesting, it can trigger new conceptual ideas as well.

ADD A MOOD

The same list item can look entirely different, depending on the tone of the execution. You can draw the same entry as a funny image, a moody image, a dynamic image, or a quiet image and get drastically different results. Feel free to draw different interpretations of the same entry.

PICK AN ART MOVEMENT

Use your favorite periods of art history or contemporary and historical illustration to influence your execution if the list calls for it. If you admire the work of animators from the 1950s, let it show in your response. Allow the execution style to affect the concepts that you develop.

CHOOSE A PERSONA

Invent a character for yourself as the creator and create from that perspective. Name your character. This simple exercise can be enough to break old habits.

LISTEN TO MUSIC

Try drawing while listening to music from different genres. Classical music can influence your drawing in one direction, while folk metal may yield a completely different visual response.

CHOOSE A VISUAL RULE AND FOLLOW THROUGH

You may choose to make your images all delicate and tiny, all smooth, or all rough. You may choose to make them entirely out of circles or squares, from scraps of ephemera pasted into your sketchbook, or without taking your pencil off the paper. Just like limiting your tools, you can place other limitations on your work to unlock directions that might otherwise go unexplored.

LISTS

FULLY
ILLUSTRATED LISTS
TO **KICK−START**
CREATIVE
THINKING

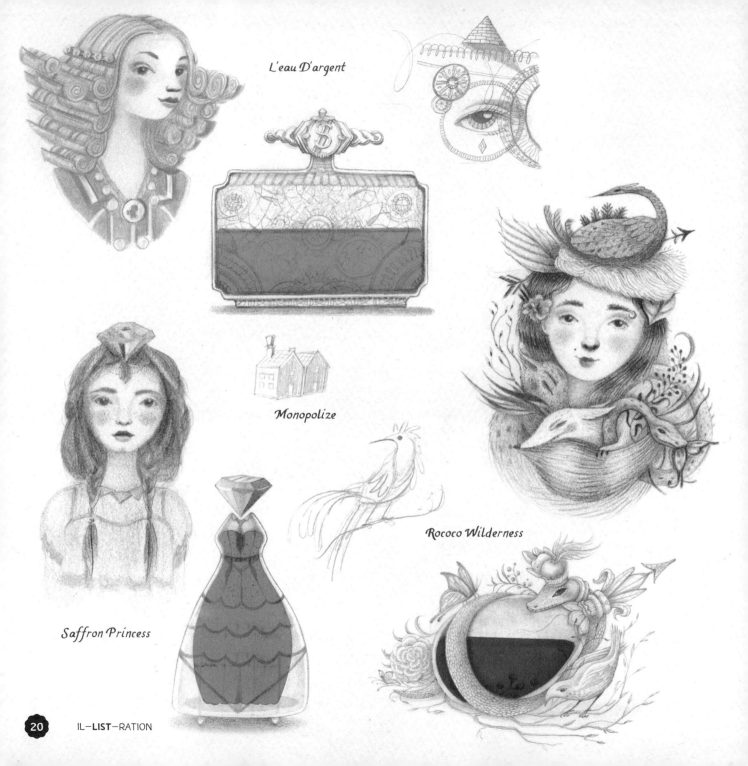

L'eau D'argent

Monopolize

Saffron Princess

Rococo Wilderness

Extravagant Perfumes

I started by conjuring up words that come to mind when I think about the word "extravagant" and listed them. Then I used wordplay, rhyming, alliteration, and combining words on my list to create perfume titles.

When illustrating, I thought about what interests me most about perfume. I immediately imagined elaborate bottles and started drawing. Then I dreamt up characters who embody the spirit of these perfumes and had fun associating them with the bottles.

1. Flight of The Bumble Bee
2. Rodeo Gold
3. Caviar Star
4. The Other Chanel
5. Intelligentsia Red
6. L'eau D'argent
7. Gill
8. Rococo Wilderness
9. Plethora Society
10. Debonair Douse
11. King Winkering's Bounty
12. Infinity Times Infinity
13. Monopolize
14. Queen Mary Mist
15. Saffron Princess

Infinity times Infinity

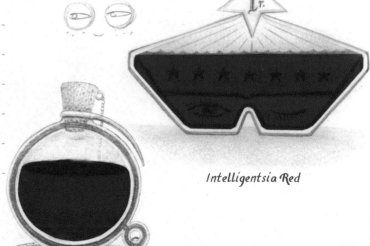

Intelligentsia Red

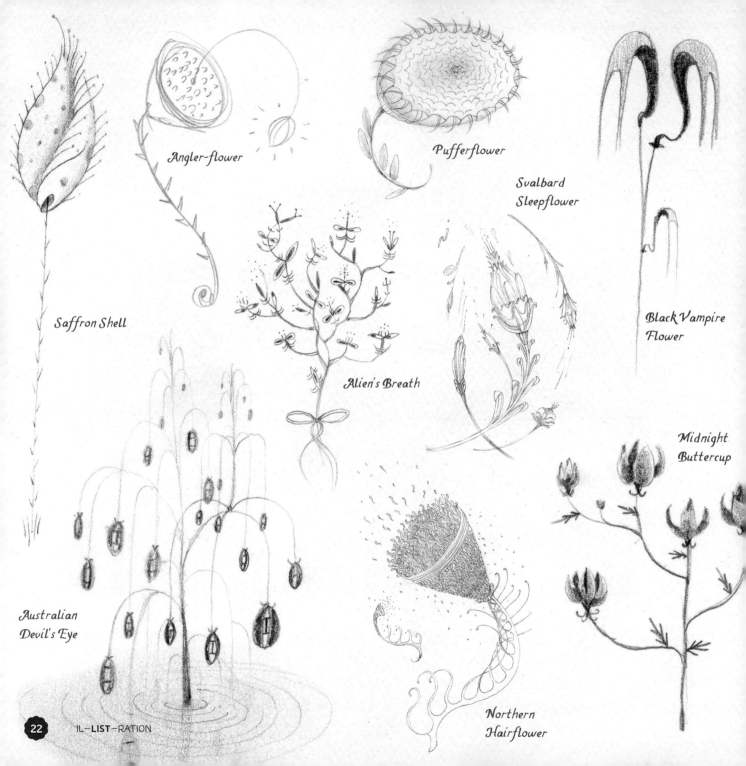

Angler-flower

Pufferflower

Svalbard
Sleepflower

Saffron Shell

Black Vampire
Flower

Alien's Breath

Midnight
Buttercup

Australian
Devil's Eye

Northern
Hairflower

Magnificent Flowers

Here I began by jotting down place names using the concept of regional plants. Svalbard, Australia, Siam, outer space, the North and the South were listed as possibilities. With this combination of plants and places, I was immediately able to start my list with detail, and it became easier to complete from there.

1. Alien's Breath
2. Lemon Belle Gargantua
3. Sailor Moonflower
4. Tibetan Exploding Fireflower
5. Saffron Shell
6. Lucky Siamese Clover
7. Southern Hairflower
8. Northern Hairflower
9. Robot Flower
10. Pufferflower
11. Black Vampire Flower
12. Australian Devil's Eye
13. Svalbard Sleepflower
14. Angler-flower
15. Midnight Buttercup

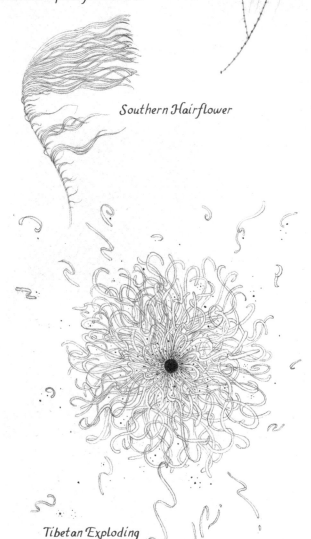

Lucky Siamese Clover

Southern Hairflower

Tibetan Exploding Fireflower

Robot Flower

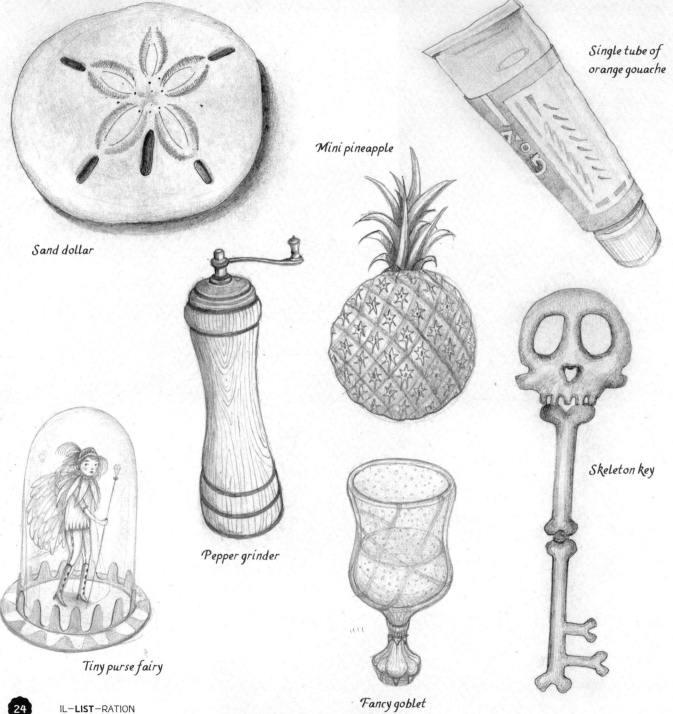

Sand dollar

Single tube of orange gouache

Mini pineapple

Pepper grinder

Skeleton key

Tiny purse fairy

Fancy goblet

Strange Items in a Purse

The challenge of this list is how open the possibilities are. A vague list can be approached in a number of ways. One option would have been to add another descriptor to help limit the possibilities and invite a specific direction of thought. In this case, I opted for an open approach and visualized people I know or have come in contact with pulling random items from their purses. The result is fun and strange.

Rubber band ball

1. Pepper grinder
2. Cicada wing
3. Skeleton key
4. Christmas snack cake (in April)
5. Single tube of orange gouache
6. Baggie of googly eyes
7. Rubber band ball
8. Sand dollar
9. Mini pineapple
10. Tiny purse fairy
11. Unidentifiable egg with drawn on smiley face
12. Calamari to go
13. Bikini
14. Fancy goblet

Unidentifiable egg with drawn-on smiley face

Cicada wing

Christmas snack cake (in April)

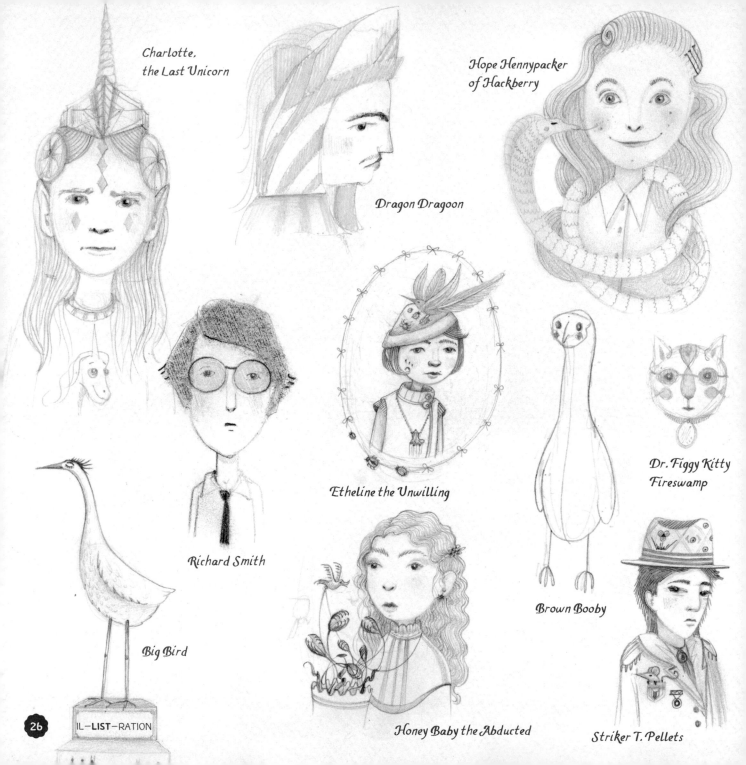

Charlotte, the Last Unicorn

Dragon Dragoon

Hope Hennypacker of Hackberry

Richard Smith

Etheline the Unwilling

Dr. Figgy Kitty Fireswamp

Big Bird

Brown Booby

Honey Baby the Abducted

Striker T. Pellets

IL–**LIST**–RATION

Cult Leaders

This list was an exercise in writing and drawing at the same time. I went back and forth between text and image, and in some cases, I waited to match the drawings to the names for an element of surprise. With this list, I can try scrambling the names with the drawings to brainstorm the potential for new and unexpected narratives.

1. Hope Hennypacker of Hackberry
2. Dragon Dragoon
3. Fortune-Telling Fish
4. Sister Othello Snake Eyes
5. Charlotte, The Last Unicorn
6. Dr. Figgy Kitty Fireswamp
7. Miracle Snail
8. Etheline The Unwilling
9. Honey Baby The Abducted
10. Brown Booby
11. Master Slugworth
12. Richard Smith
13. Big Bird
14. Bird Queen Beatrice
15. Striker T. Pellets
16. Gertrude Gray The Eighth

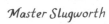

Master Slugworth

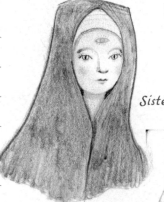

Sister Othello Snake Eyes

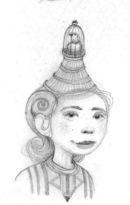

Bird Queen Beatrice

Gertrude Gray
the Eighth

Fortune-Telling Fish

Miracle Snail

Map to mystery spot

Unexplainable eye

Cult sticker

Unreadable letter

Strange scientific markings

Peculiar collage

Half Tarot

Mystery Ephemera

These images sprung from a decision about technique. I found scraps of interesting paper to glue down or created scrap shapes with gouache as a base for drawing. Simply removing the daunting white of the page first can help conquer creative blocks and allow for instinctual play.

1. Map to mystery spot
2. Peculiar collage
3. Suspicious napkin
4. Cult sticker
5. Unexplainable eye
6. Ticket to the moon
7. Strange scientific markings
8. Faceless photo
9. Coded matchbook
10. Unmarked package
11. Unreadable letter
12. Half tarot
13. Metaphysical gauge
14. Catalog card

Coded matchbook

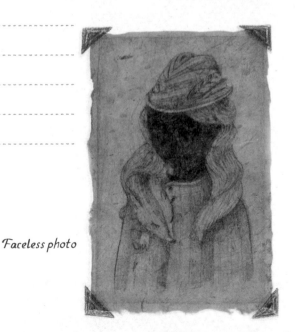
Faceless photo

Metaphysical gauge

Unmarked package

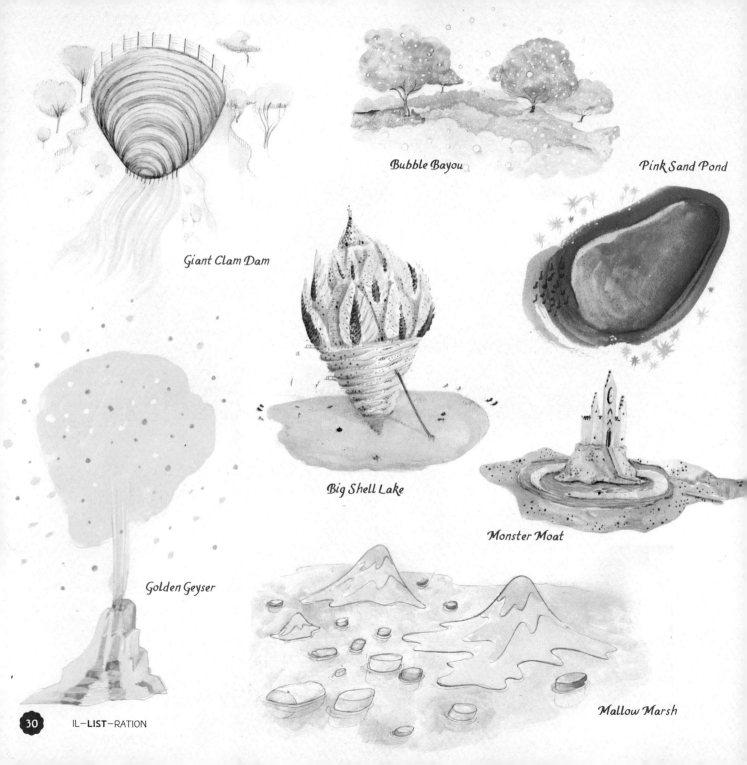

Bubble Bayou

Pink Sand Pond

Giant Clam Dam

Big Shell Lake

Monster Moat

Golden Geyser

Mallow Marsh

Remarkable Bodies of Water

To attack this list, I started with an Internet search of names for types of bodies of water. I wrote down about forty different options. From there, I played with alliteration, rhyming, and adding in items I simply wanted to draw.

1. Giant Clam Dam
2. Bubble Bayou
3. Pink Sand Pond
4. Fragrant Falls
5. Big Shell Lake
6. Venn Cove
7. Shell Cave Lagoons
8. Golden Geyser
9. Mallow Marsh
10. Ghost Ship Shallows
11. Boiling Point Pond
12. Monster Moat

Fragrant Falls

Shell Cave Lagoons

Venn Cove

Boiling Point Pond

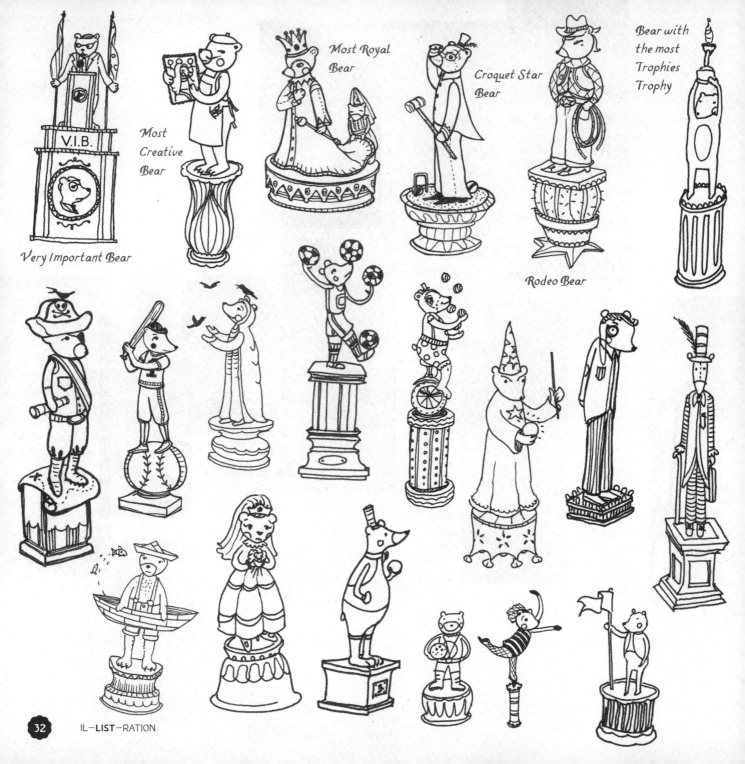

Most Royal Bear

Croquet Star Bear

Bear with the most Trophies Trophy

Most Creative Bear

V.I.B.

Very Important Bear

Rodeo Bear

IL-**LIST**-RATION

Trophies for Bears

This was the quirkiest and most liberating of the lists, which allowed me to draw without restricted thought. The visual ideas here came out more quickly than words, so I found it easier to doodle any and all possibilities, flowing from one to the next without ruling out any ideas. Remember that there is no correct way to create and draw your lists. Your written responses and drawings do not have to match exactly. The objective is simply to keep drawing.

1. Strongest Bear
2. Best Villain Bear
3. Best Baker Bear
4. Super Surfer Bear
5. Raddest Bear
6. Beauty Bear
7. Very Important Bear
8. Most Creative Bear
9. Most Royal Bear
10. Croquet Star Bear
11. Rodeo Bear
12. Yogi Bear
13. Bowling Bear
14. Bear With The Most Trophies Trophy
15. Most Wild Bear

Best Villain Bear

Beauty Bear

Best Baker Bear

Super Surfer Bear

Strongest Bear

Raddest Bear

Yogi Bear

Most Wild Bear

Bowling Bear

Eye of the Purple People Eater—
For lightness on one's feet

Marble Marl—Moderates anger

Spotty Popper—
Plant this in the
garden and love
will manifest

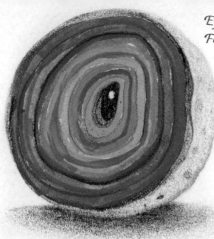

Geoquartz—Helps with
left-brain problems

Harzburgite Horizon—
Brings about
a cheerful
demeanor

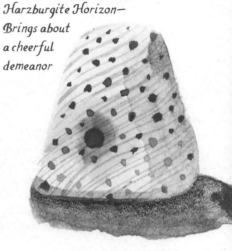

Unicorn Bloodstone—Purifies negativity and evil

Purslane Pyramid—
Sleep inducing

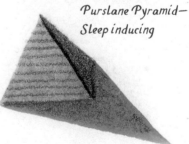

Northern
Lightstone—
Worn to
bring luck

Venus Poolstone—Halts gossip

Spiky Moon Beast—Enhances your natural
qualities for nefarious purposes

Minerals and Their Properties

I started here by looking through a book on rocks and minerals. I came up with fantastic names for real stones. I then took my creative names and painted new visuals inspired by them. Creating a list that is grounded in the real world and drawing fantastic elements from it is one approach to the list exercise. Alternatively, creating a fantasy list and matching drawings of real-world items could be another.

1. Eye of The Purple People Eater—For lightness on one's feet
2. Unicorn Bloodstone—Purifies negativity and evil
3. Spotty Popper—Plant this in the garden and love will manifest
4. Pink Death—Highly Toxic, but one can see predictive visions when it doesn't kill
5. Purslane Pyramid—Sleep inducing
6. Venus Poolstone—Halts gossip
7. Pox Rocks—Orange give you the Pox, yellow is the antidote
8. Northern Lightstone—Worn to bring luck
9. Marzburgite Horizon—Brings about a cheerful demeanor
10. Marble Marl—Moderates anger
11. Lime Loomstone—Brings wealth to those who would deserve it
12. Geoquartz—Helps with left-brain problems
13. Firepede—Occasional miracles are reported around Firepede
14. Spiky Moon Beast—Enhances your natural qualities for nefarious purposes

Lime Loomstone—Brings wealth to those who would deserve it

Pox Rocks— Orange give you the Pox, yellow is the antidote

Pink Death—Highly toxic, but one can see predictive visions when it doesn't kill

Firepede—Occasional miracles are reported around Firepede

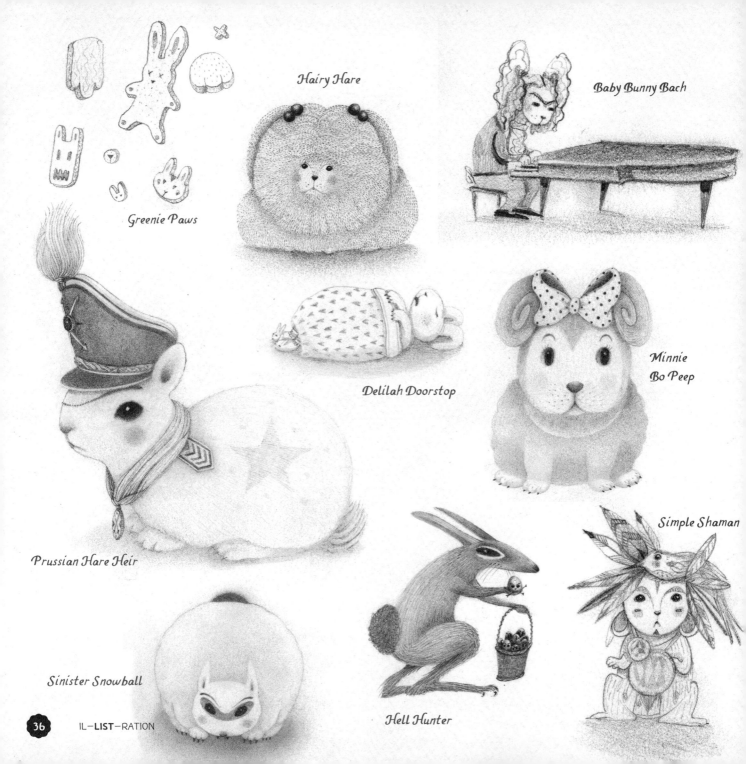

Greenie Paws

Hairy Hare

Baby Bunny Bach

Prussian Hare Heir

Delilah Doorstop

Minnie
Bo Peep

Sinister Snowball

Hell Hunter

Simple Shaman

Blue Ribbon Rabbits

Though I've never had a pet rabbit myself, I started with characteristics of pets in general to create this list. I considered the range of temperaments possible in a pet and added in visual references to create character names that could elicit both aesthetic and personality traits. From there, I added in qualities of pets I've known and referenced images of rabbits to expand the range of sizes and shapes I tackled.

1. Cupcakes
2. Greenie Paws
3. Simple Shaman
4. Baby Bunny Bach
5. Hairy Mare
6. Prussian Mare Meir
7. Delilah Doorstop
8. Prince of Marfa
9. Minnie Bo Peep
10. Chuckles
11. Hell Hunter
12. Sinister Snowball
13. Princess Buttercup

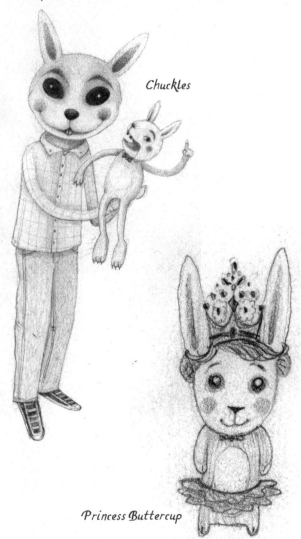

Chuckles

Princess Buttercup

STARTER

LISTS

COMPLETE
THESE LISTS TO
KICK—START
CREATIVE ACTION

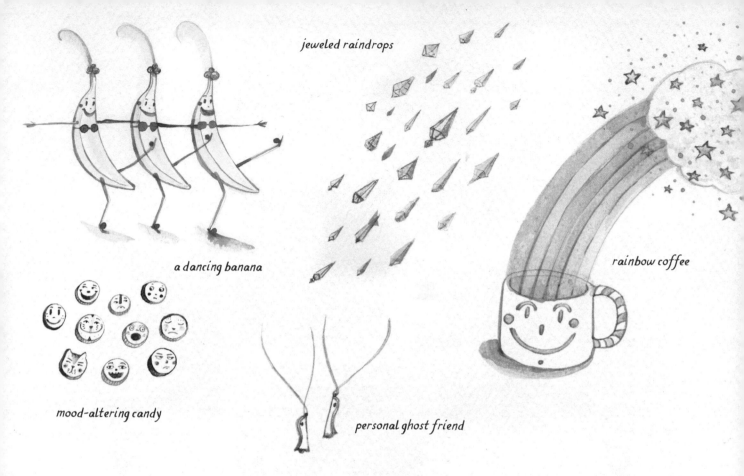

a dancing banana

jeweled raindrops

rainbow coffee

mood-altering candy

personal ghost friend

Small Miracles

To attack this list, I had to define "small miracles" as I see them. I decided that small miracles could be personal miracles witnessed by only a few people. Small miracles may not be life-changing but could quite possibly be day-changing.

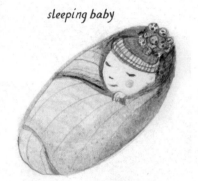

synchronized stingrays

1. a dancing banana
2. rainbow coffee
3. synchronized stingrays
4. personal ghost friend
5. mood-altering candy
6. sleeping baby
7. jeweled raindrops
8. all the green candies
9.
10.
11.
12.
13.
14.
15.

sleeping baby

all the green candies

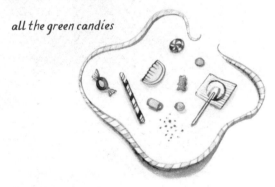

Phoenix Firefly

Katydid Kupid

Hudson Glass Slider

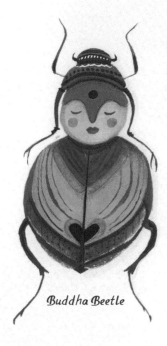

Buddha Beetle

Assassin Bug Assassin

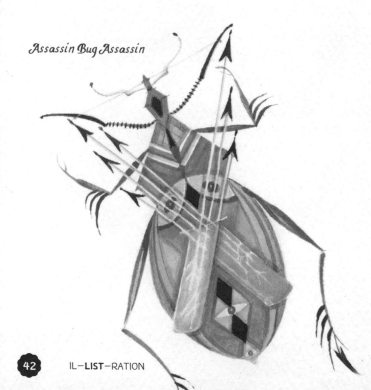

Helpful Bugs

This list was brainstormed with my family while we were on a car trip. It was fun to get input from those who brainstorm without necessarily worrying about the visual outcome. Some of their ideas made the list and prompted the remaining list items. Soliciting others for words and ideas outside of your head is a fun and unexpected way to begin a project.

1. Mudson Glass Slider
2. Assassin Bug Assassin
3. Wentley The Weaving Weevil
4. Cat-Faced Pond Skimmer
5. Buddha Beetle
6. Phoenix Firefly
7. Lady Lovebug
8. Katydid Kupid
9. Lighthouse Lacewings
10. Lucky Bug
11.
12.
13.
14.
15.

Lucky Bug

Lady Lovebug

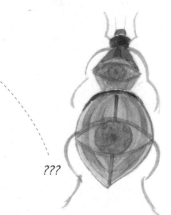

???

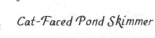

Cat-Faced Pond Skimmer

Bicycle wheels

Jewels

Gears

Petri Dish

Donut

Planets

Ice cream scoops

Sunflowers

The sun

Use the blank circles as a place to start

Inspired by Circles

Starting with a shape is a fun way to immediately put pen to paper. Continue the exercise by playing with the supplied dots for your own creations. I found these stickers at an office supply store. Extend the exercise by finding other objects or standardized shapes from which to doodle.

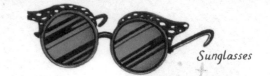

Sunglasses

Beetles

1. Bicycle wheels
2. Sunflowers
3. Jewels
4. Donut
5. Ice cream scoops
6. The sun
7. Planets
8. Beetles
9. Gears
10. Petri dish
11. Sunglasses
12.
13.
14.
15.

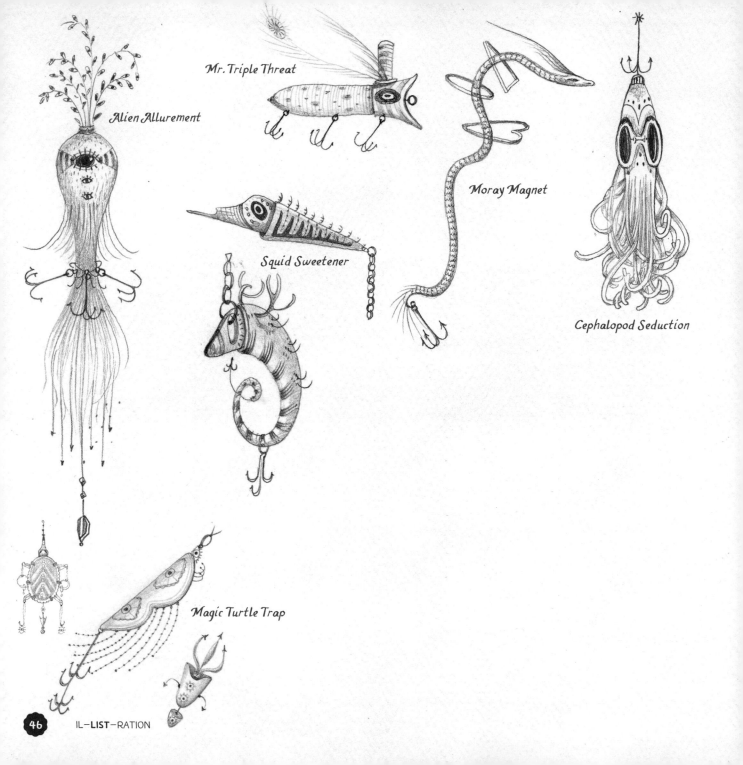

Alien Allurement

Mr. Triple Threat

Moray Magnet

Squid Sweetener

Cephalopod Seduction

Magic Turtle Trap

For Fancy Fishermen

For this list, I immediately focused on elaborate fishing lures because there was visual interest there for me. Feel free to consider any and all potential aspects of fancy fishing as you continue with this list. Fishing poles, luxury boats, gourmet snack food, fanciful hats, special clothing, high-end coolers, and accessories are all fair game.

1. Lanternfish Lure
2. Alien Allurement
3. Cephalopod Seduction
4. Siren Song Gold Series
5. Mr. Triple Threat
6. Magic Turtle Trap
7. Moray Magnet
8. Squid Sweetener
9.
10.
11.
12.
13.
14.
15.

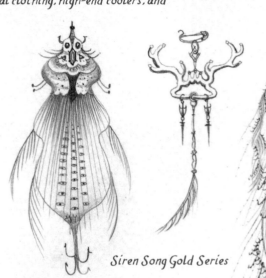

Siren Song Gold Series

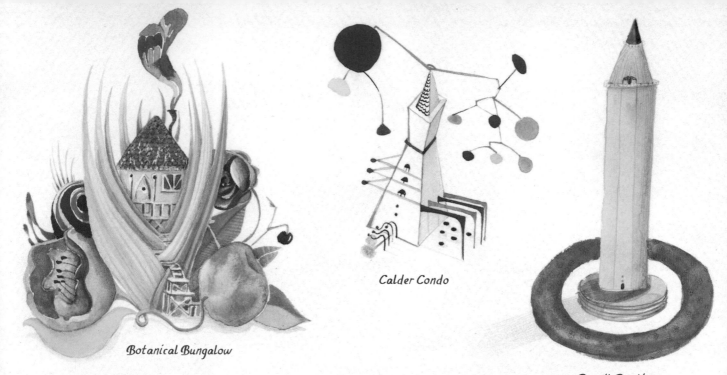

Botanical Bungalow

Calder Condo

Pencil Penthouse

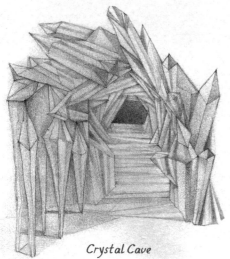

Crystal Cave

Eclectic Homes

This topic was overwhelming for me until I decided not to take it too seriously and to create fun and silly responses. "Pencil Penthouse" incorporates a tall graphic shape that was enjoyable to draw, and after painting a bunch of minerals earlier in the book, I wanted to continue exploring textures to make a "crystal cave." Try looking up types of dwellings and combine them with a wildcard word to depict something new.

1. Pencil Penthouse
2. Calder Condo
3. Botanical Bungalow
4. Turtle Trullo
5. Tallest Teepee
6. Crystal Cave
7. Regal Rowhome
8. Canine Casa
9.
10.
11.
12.
13.
14.
15.

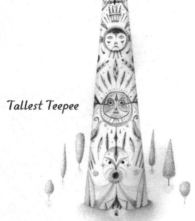

Tallest Teepee

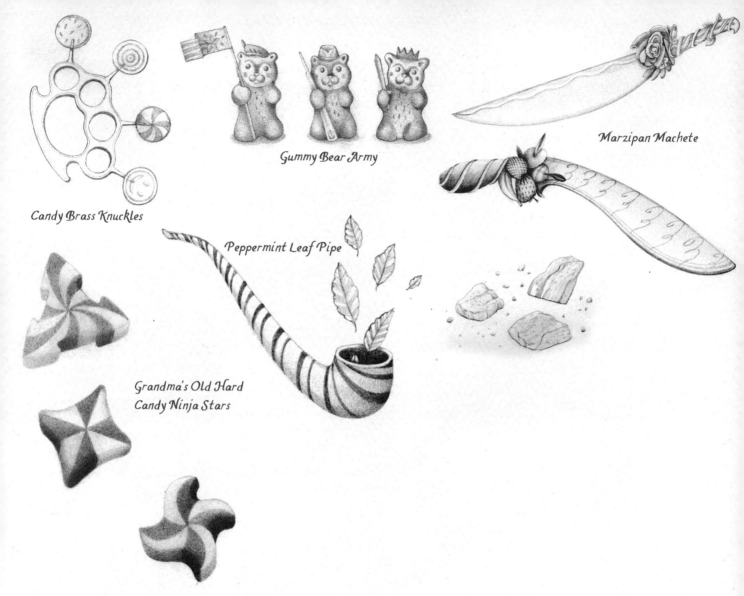

Candy Brass Knuckles

Gummy Bear Army

Marzipan Machete

Peppermint Leaf Pipe

Grandma's Old Hard
Candy Ninja Stars

Dangerous Candy

The juxtaposition of candy types and dangerous objects makes for some interesting combinations. Continue this with your favorite candies and weapons or invent your own of either category for this mash-up. Make two separate lists and play with the possible combinations for fun results. What do you consider the opposite of dangerous? You could also start there. Could you make a kitten look dangerous by drawing it with a spiked candy collar and candy brass knuckles?

1. Peppermint Leaf Pipe
2. Marzipan Machete
3. Gummy Bear Army
4. Exploding Volcano Rocks
5. Candy Brass Knuckles
6. Ghost Pepper Hot Tamales
7. Grandma's Old Hard Candy Ninja Stars
8.
9.
10.
11.
12.
13.
14.

Exploding Volcano Rocks

Ghost Pepper Hot Tamales

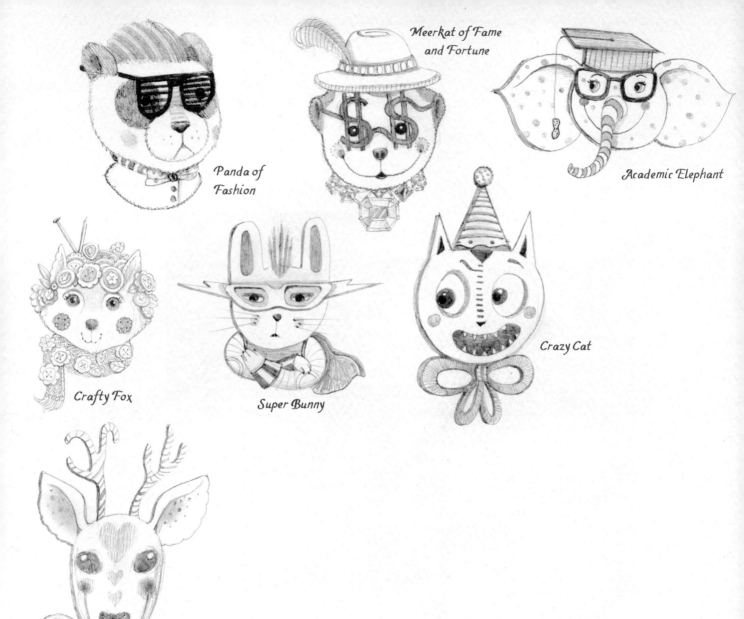

Panda of Fashion

Meerkat of Fame and Fortune

Academic Elephant

Crafty Fox

Super Bunny

Crazy Cat

Sweetheart Deer

Spirit Animal Totems

Mixing animals I wanted to draw with character traits was my simple process here. In lieu of traditional totems, I opted for playful and silly characters. While you can always mix media and styles and approaches within any list, sometimes it is a good exercise to consider the imagery as a small collection and practice consistency in style, medium, or palette.

Subversive Squid

1. Panda of Fashion
2. Meerkat of Fame and Fortune
3. Academic Elephant
4. Crafty Fox
5. Super Bunny
6. Crazy Cat
7. Subversive Squid
8. Sweetheart Deer
9. Wild Warthog
10.
11.
12.
13.
14.
15.

FREE-PLAY

LISTS

FRESH LISTS
FROM WHICH TO
LAUNCH YOUR
**CREATIVE
EMPIRE**

What do you drink every day?

What mundane daily rituals do you wish a potion might remedy?

Can you mix these lists to develop your own elixirs?

Everyday Potions

1.
2.
3.
4.
5.
6.
7.
8.
9.
10.
11.
12.
13.
14.
15.

Which awards would you most like to win, given unlimited abilities and circumstances?

What monumental or small honors do you wish existed?

Can you design fitting rewards for these accomplishments?

Awards to Win

1.
2.
3.
4.
5.
6.
7.
8.
9.
10.
11.
12.
13.
14.
15.

What resources might be
found at an office?

What are some examples of
traditional craft projects?

Mix and match your results for
the most dramatic effect.

Cubicle Crafts

1. ...
2. ...
3. ...
4. ...
5. ...
6. ...
7. ...
8. ...
9. ...
10. ..
11. ..
12. ..
13. ..
14. ..
15. ..

Begin by dreaming up
specific clown characters.

Give each a clown name, a real
name, and a backstory.

Then let the items in their pockets
reveal intriguing narratives.

Items in a Clown's Pocket

1. ..
2. ..
3. ..
4. ..
5. ..
6. ..
7. ..
8. ..
9. ..
10. ..
11. ..
12. ..
13. ..
14. ..
15. ..

What's your sign?

Can you mix traditional zodiac symbols and traits with modern ideas?

Or ditch the past and invent a new collection of birth mascots for future generations.

Ultramodern Astrological Symbols

1.
2.
3.
4.
5.
6.
7.
8.
9.
10.
11.
12.
13.
14.
15.

Here is your chance to draw
all of the random items in your
"mystery drawer."

Play with shapes and color to
create missing pieces to machines or
toys (long lost or newly invented).

Missing Pieces

1.
2.
3.
4.
5.
6.
7.
8.
9.
10.
11.
12.
13.
14.
15.

Who are Narwhal's
best friends?

What are their names?

Give each a first, middle, and last
name and then draw their portraits.

Which one physical and one
personality trait make
each stand out?

Narwhal's Best Friends

1. ..
2. ..
3. ..
4. ..
5. ..
6. ..
7. ..
8. ..
9. ..
10. ...
11. ...
12. ...
13. ...
14. ...
15. ...

Start by jotting down
silly names and sweet treats.

Mix your names with current and
historic fashion styles.

Add some personality quirks
and the characters will begin to
write and draw themselves.

Predecessors to Wonka

1. ..
2. ..
3. ..
4. ..
5. ..
6. ..
7. ..
8. ..
9. ..
10. ...
11. ...
12. ...
13. ...
14. ...
15. ...

Can you think of the most impractical and grandiose housewarming gifts?

What next-best thing might you imagine popping up on home shopping channels or imaginary malls in the sky?

You may also direct your search toward small luxuries with fleeting value.

Things You'll Want but Will Never Use

1. ...
2. ...
3. ...
4. ...
5. ...
6. ...
7. ...
8. ...
9. ...
10. ..
11. ..
12. ..
13. ..
14. ..
15. ..

Start here by listing
today's most common emojis.

Can you add or update these?

Try to tell an emoji-only story about
a typical day. Then try your
hand at a fairy tale or an
extraordinary event.

Advanced Emojis

1.
2.
3.
4.
5.
6.
7.
8.
9.
10.
11.
12.
13.
14.
15.

Make a list of regular office supplies.

Make a list of luxury items.

Play with combinations of these lists to great effect. Be as wasteful as you possibility can.

IL-**LIST**-RATION

Office Supplies for Millionaires

1. ..
2. ..
3. ..
4. ..
5. ..
6. ..
7. ..
8. ..
9. ..
10. ..
11. ..
12. ..
13. ..
14. ..
15. ..

*Which holidays will be
around in the future?*

*Be creative, take this Monday off
of work, and invent some new ones.*

*Draw new saints, new idols,
new symbols, and new supplies for
the holidays of the future.*

Brand-New Holidays

1.
2.
3.
4.
5.
6.
7.
8.
9.
10.
11.
12.
13.
14.
15.

Think of superheroes you
have known and loved.

Make up new ones. Mix these
with babies you like, love, or
are indifferent to.

What do they look like doing super
things? What do they look
like doing baby things?

Baby Superheroes

1.
2.
3.
4.
5.
6.
7.
8.
9.
10.
11.
12.
13.
14.
15.

What small-town feats, curiosities, and features might you imagine on which to base a profitable attraction?

How might these towns create monuments to victories or accomplishments that warrant a highway exit for a quick, one-of-a-kind selfie?

Roadside Attractions

1.
2.
3.
4.
5.
6.
7.
8.
9.
10.
11.
12.
13.
14.
15.

Real or imagined, from life or fable, what are the loudest things and why?

Vent your frustrations with those maniacal birds that wake you up before dawn, or invent your own zoo of rare species or classroom full of characters.

The Loudest Things

1.
2.
3.
4.
5.
6.
7.
8.
9.
10.
11.
12.
13.
14.
15.

Carnival games seem like unlikely bets. But how can you up the ante and make them entirely impossible?

Can you make a list of seemingly impossible things and blend your ideas into these games?

Have fun drawing games, prizes, and signage here.

Impossible Carnival Games

1.
2.
3.
4.
5.
6.
7.
8.
9.
10.
11.
12.
13.
14.
15.

Professional wrestling
has been around for some time, but
can it compete with prime time?

Try mixing cutting-edge fashion,
technology, or science with the world
of wrestling. This list goes for all
forms of professional or athletic
wrestling, including the
Olympic sport itself.

Cutting-Edge Professional Wrestlers

1.
2.
3.
4.
5.
6.
7.
8.
9.
10.
11.
12.
13.
14.
15.

Write a list of magical places remembered or researched from storybooks, novels, and experiences from your youth.

What rules (visual and otherwise) exist in these places that do not exist in ordinary spaces?

Magical Places

1.
2.
3.
4.
5.
6.
7.
8.
9.
10.
11.
12.
13.
14.
15.

What kinds of pies can you find everywhere?

What kinds of pies can you find nowhere?

What kinds of pies do you wish there were? Think simple and then elaborate and create a case of culinary wonders.

Unusual Pies

1. ..
2. ..
3. ..
4. ..
5. ..
6. ..
7. ..
8. ..
9. ..
10. ...
11. ...
12. ...
13. ...
14. ...
15. ...

Princesses have earned a bad reputation in some quarters because of their dainty ways.

What types of princesses remain unrepresented? Think in terms of culture, attitude, style, special talents, and goals to create radical princesses of the future.

Radical Princesses

1.
2.
3.
4.
5.
6.
7.
8.
9.
10.
11.
12.
13.
14.
15.

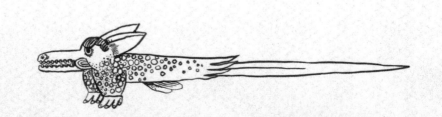

GUEST

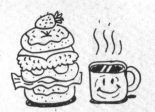

LISTS

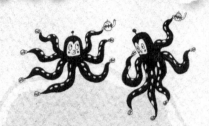

FULL AND
HALF LISTS BY
TOP ILLUSTRATORS
IN THE FIELD

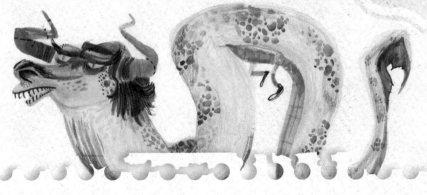

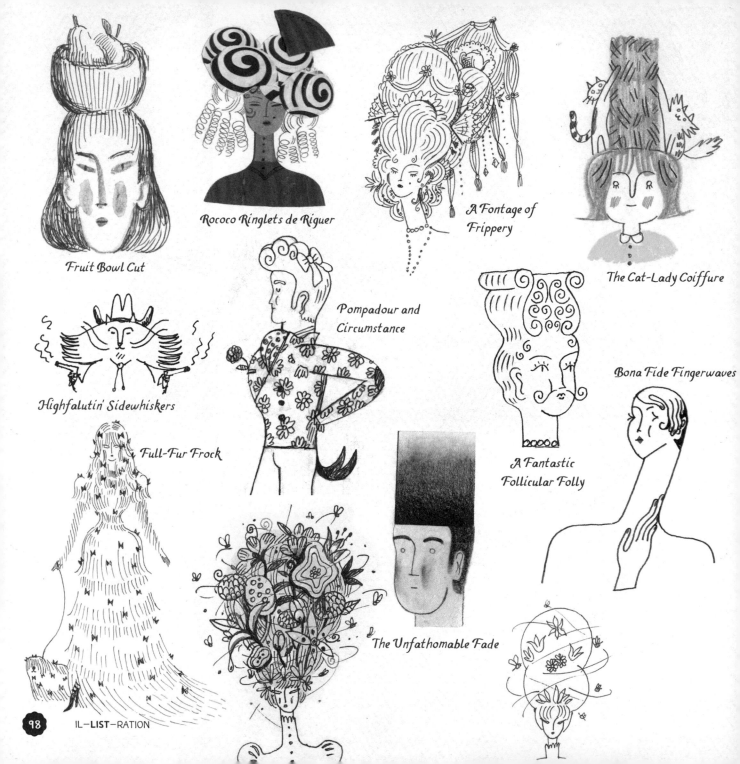

Fruit Bowl Cut

Rococo Ringlets de Riguer

A Fontage of Frippery

The Cat-Lady Coiffure

Highfalutin' Sidewhiskers

Pompadour and Circumstance

Bona Fide Fingerwaves

Full-Fur Frock

A Fantastic Follicular Folly

The Unfathomable Fade

Formal Hairstyles

Julianna Brion

My suggestion is to write down lots and lots of words. They can come from anywhere—what you had for dinner last night, your favorite animal, or even just words you like the sound of. Sometimes seeing different words written down on the same page can lead to connections your brain wouldn't otherwise make.

1. Rococo Ringlets de Riguer
2. Fruit Bowl Cut
3. The Unfathomable Fade
4. Highfalutin' Sidewhiskers
5. A Fontage of Frippery
6. The Regal Beehive
7. Hairdo Askew
8. A Fantastic Follicular Folly
9. The Austere Ought-not
10. Full-Fur Frock
11. Bona Fide Fingerwaves
12. Divine Drapery
13. The Cat-Lady Coiffure
14. A Dandy's Duncecap
15. Top-Notch Tonsure
16. Pompadour and Circumstance
17. A Young Baron's Buzzcut

Hairdo Askew

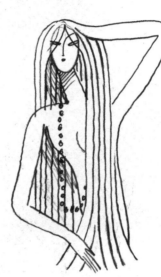

Divine Drapery

A Dandy's Duncecap

Top-Notch Tonsure

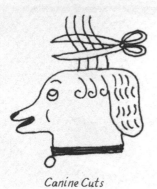

Canine Cuts

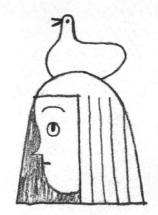

Avant Garde Headgear

A fish aficionado

Tip Top Topiaries

Crypto Queen, hunter of mythological creatures

Tongue Twister Sister

New Girl Scout Badges

Julianna Brion

1. Canine Cuts
2. Crypto Queen, hunter of Mythological creatures
3. Lasso Lass of The Master class
4. Tongue Twister Sister
5. A fish aficionado
6. Avant Garde Headgear
7. Tip Top Topiaries
8.
9.
10.
11.
12.
13.
14.
15.

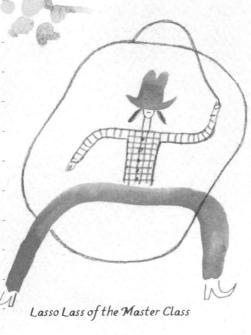

Lasso Lass of the Master Class

Sturgeon Curmudgeon

The Silky-Spiny Urchinchilla

Amateurish Anglerfish

Eelka Meano

Odd Descender

Neptune's Hippocamp Firebrand

Lobsteriffic!

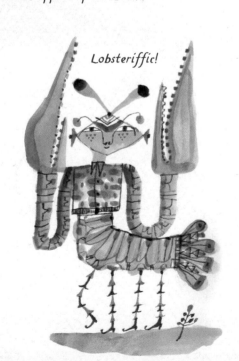

The Octapologist Eight
indiscretions await confessions.

Abyssal Snail

Deep-Sea Creatures

Calef Brown

Depthusiastic
Life Forms

When brainstorming from the initial prompt, I let my mind wander and see what associations come up. I find myself speaking some of the associated words or phrases aloud. Riffing off of them for their sound as well as the images they conjure are both important. When I have a group of word ideas, I bounce back and forth between drawing and writing, trying to find characters and objects that have presence and can begin to tell a story.

1. Sturgeon Curmudgeon
2. The Silky-Spiny Urchinchilla
3. Pressure Crusher Prawn
4. Amateurish Anglerfish
5. Pour Ghee on a Porgie
6. Anchovial Worm
7. Depthusiastic Life Forms
8. Abyssal Snail
9. Oafish Wolffish
10. The Last Aquatic Terracuda
11. Eelka Meano
12. Recently Single Grouper
13. Man-Ray
14. The Photophoric Oracle
15. Neptune's Hippocamp Firebrand
16. Lobsteriffic!
17. Pathosphere
18. The Octapologist—Eight indiscretions await confessions.
19. Mister Edwardian Spider Crab is a guardian, a fighter, and MAD!
20. Waterpiller
21. Odd Descender
22. More or Less a Remora

Pathosphere

Mister Edwardian Spider Crab is a guardian, a fighter, and MAD!

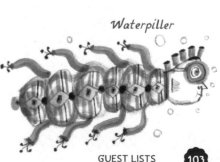

Waterpiller

Catatonicarlton

Angora Gary

Daggerwhisker Z

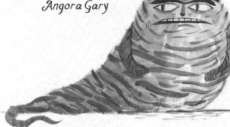

Tabitha Hutt

A fixture at Bar Fup

Clawsassin

Cheney

The Litter Boxer

Creeping Calico Chaos

Evil Cat Names

Calef Brown

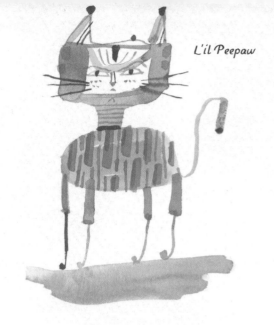

L'il Peepaw

1. DaggerWhisker Z
2. Clawsassin
3. Angora Gary
4. Mister Nibblepoppy
5. A fixture at Bar Fup
6. The Caterwaul of Voodoo
7. Cheshire Brushfire
8. Tabitha Mull
9. Apocalynx Meow
10. Cheney
11. The Litter Boxer
12. Creeping Calico Chaos
13. Catatonicarlton
14. L'il Peepaw
15. Puss in Wingtips (on backwards)
16.
17.
18.

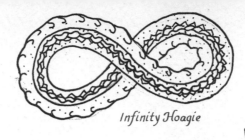
Infinity Hoagie

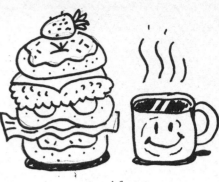
Breakfast Burger

B.L.M.N.O.P.Q.R.S.T.
(or B.L.ETC.) Stands for Bacon
Lettuce Mayo Nacho Cheese
Onion Pizza Quiche Ramps
Sardines Tomatoes

Extra Crust

Extra Crust PB&J

PB&J (Crust Lovers)

Dag(red)wood

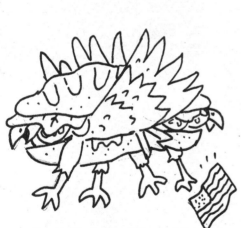
Double Eagle Steak Sandwich
(takes two eagles to make one
steak, preferably bald)

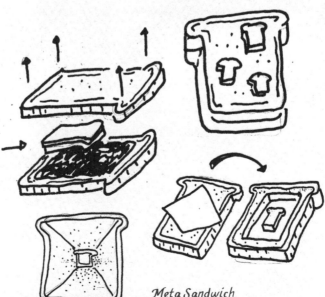
Meta Sandwich

Sandwiches I'd Like to Eat

Mikey Burton

It's important to try new approaches, and one of the easiest ways to do this is through experimentation. I was going through a creative slump a year ago, and I gave myself the challenge of simply drawing everything I ate during the day. These little daily food experiments ultimately led me out of my slump and into some fun creative territory (and even some new clients, too).

1. B.L.M.N.O.P.Q.R.S.T. (or B.L.ETC)
 Stands for Bacon Lettuce Mayo
 Nacho Cheese Onion Pizza Quiche
 Ramps Sardines Tomatoes
2. Infinity Hoagie
3. Breakfast Burger
4. Guilt-free Sando
5. Breakfast Sandwich. All day. Anytime.
 24-7, 365 days a year.
6. Double Eagle Steak Sandwich
 (Takes two eagles to make one steak,
 preferably bald)
7. Meta Sandwich
8. Metaphysical Sandwich
9. 27 Club Sandwich
10. Peppermint Patty Melt
11. Dag(red)wood
12. Hamburger Party Sub
13. Submarine Sandwich with
 Bread Periscope
14. The Overhang (a double-decker
 sandwich with a little extra on top)
15. Extra Crust PB&J

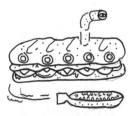

Submarine Sandwich
with Bread Periscope

Guilt-free Sando

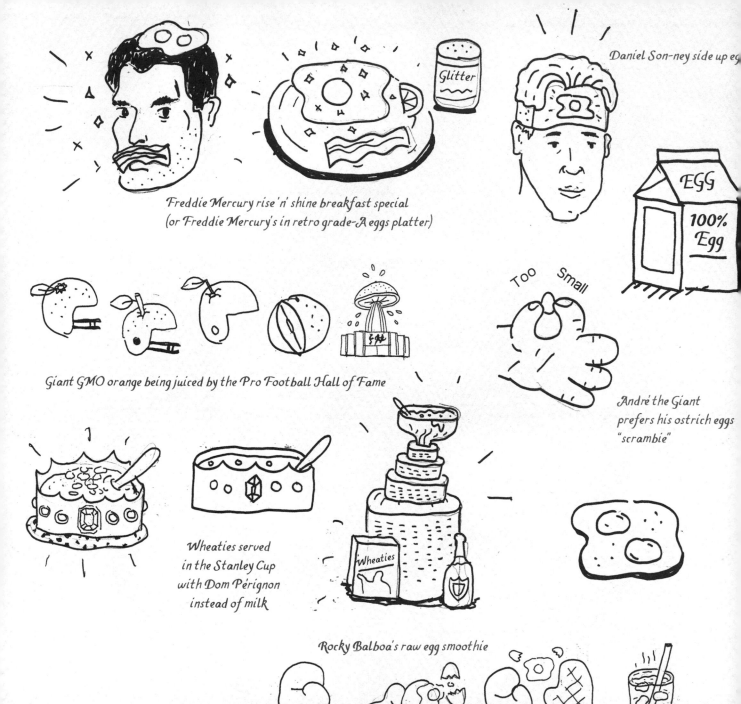

Daniel Son-ney side up egg

Freddie Mercury rise 'n' shine breakfast special
(or Freddie Mercury's in retro grade-A eggs platter)

EGG
100%
Egg

Giant GMO orange being juiced by the Pro Football Hall of Fame

Too Small

André the Giant prefers his ostrich eggs "scrambie"

Wheaties served
in the Stanley Cup
with Dom Pérignon
instead of milk

Rocky Balboa's raw egg smoothie

oops!

Breakfasts for Champions

Mikey Burton

1. Rocky Balboa's raw egg smoothie
2. Freddie Mercury rise 'n' shine breakfast special
 (or Freddie Mercury's in retro grade-A eggs platter)
3. Michael Jordan's space jam and toast
4. Giant GMO orange being juiced by the Pro Football Hall of Fame
5. Daniel Son-ney side up egg
6. André the Giant prefers his ostrich eggs "scrambie"
7. Wheaties served in the Stanley Cup with Dom Pérignon instead of milk
8.
9.
10.
11.
12.

2157 Light Saber Baseball Leagues

Live Beaver Hats 1760

Six-Time Regional Carpet Salesman
Champion Dies at Home Alone

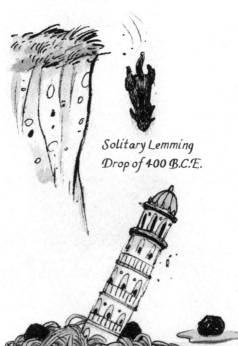
Solitary Lemming
Drop of 400 B.C.E.

Sinking of the Trojan
Narwhal—805 B.C.E.

Paul Revere "Lightning Bug
Lantern" Dry Run

Giant Pasta Noodle
Craze of 1601

Christmas Athlete's Foot
Outbreak—Norway 1921

Cereal Dust Bowl of 1994

Unrecorded Disasters

John Hendrix

Kodak
Camera-Gun
Prototype 1903

When illustrating your ideas, a very practical suggestion is to focus on nouns. It is easy to get frustrated when you're trying to illustrate abstract concepts, such as "betrayal" or "happiness." A much easier starting place is when you take your word list and look for "drawable things." Drawing "a rush-hour car wreck" is easier to draw than "having a bad day."

1. Sinking of The Trojan Narwhal—805 B.C.E.

2. 2157 Light Saber Baseball Leagues

3. Six-Time Regional Carpet Salesman Champion Dies at Home Alone

4. Kodak Camera-Gun Prototype—1903

5. Solitary Lemming Drop of 400 B.C.E.

6. Giant Pasta Noodle Craze of 1601

7. Lumber Jacking on Ice Trend of 1887

8. Bermuda Triangle Zeppelin Racing—1931

9. The First Elevator 30,000 B.C.E.

10. Live Beaver Hats 1760

11. Paul Revere "Lightning Bug Lantern" Dry Run

12. Christmas Athlete's Foot Outbreak—Norway 1921

13. The Seventeen-Way 5th Grade Science Fair 1st Place Tie of 1983

14. Cereal Dust Bowl of 1994

15. Super-Stinky-Siberian Meteorite Impact—1813

Super-Stinky-Siberian-
Meteorite Impact 1813

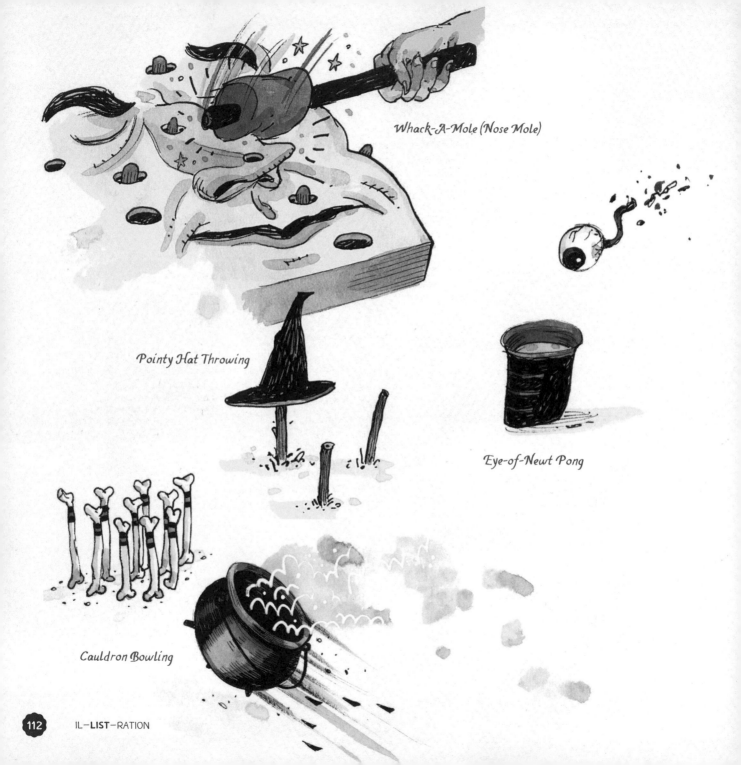

Whack-A-Mole (Nose Mole)

Pointy Hat Throwing

Eye-of-Newt Pong

Cauldron Bowling

Other Wizard Sports

John Hendrix

Wizard NASCAR

1. Dragon Shoes
2. Capture The Flag
3. Dead Toad Shuffleboard
4. Wand Darts
5. Cauldron Bowling
6. Robe Races
7. Whack-A-Mole (Nose Mole)
8. Pointy Hat Throwing
9. Eye-of-Newt Pong
10. Wizard NASCAR
11. Non-Magic Broom Floor Sweeping
12.
13.
14.

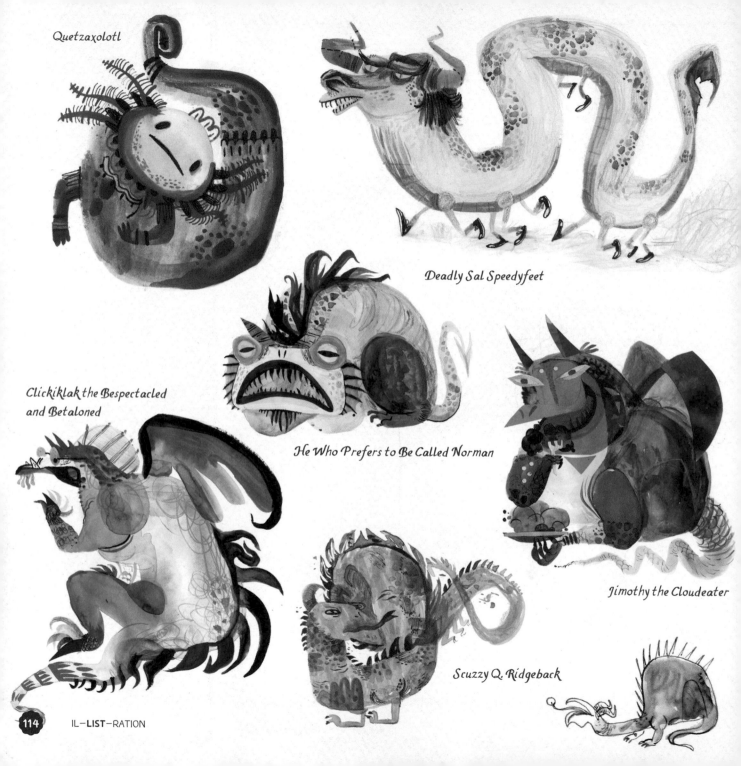

Quetzaxolotl

Deadly Sal Speedyfeet

Clickiklak the Bespectacled
and Betaloned

He Who Prefers to Be Called Norman

Jimothy the Cloudeater

Scuzzy Q. Ridgeback

IL-**LIST**-RATION

Names for Dragons

Meg Hunt

Find ways to keep it interesting. Think in terms of shape, try a color that seems counter to what you would normally use, use a new tool. For this list, I started out with mixed media but remembered I had a packet of cut-up painted paper scraps on my shelf. Collage helped me push a more unique, playful range of designs I wouldn't have come up with just by drawing.

Pleeko the Tabledrake

1. Deadly Sal Speedyfeet
2. The Grizzled Wizard Lizard
3. Lyre'rak the Literate (Guardian of the Obsidian Library)
4. Quetzaxololt
5. He Who Prefers To Be called Norman
6. Jimothy the Cloudeater
7. The Triple-skulled Gronk
8. Lanternbeak Jones
9. The Mowling Leviathan
10. Pleeko the Tabledrake
11. Clickiklak the Bespectacled and Betaloned
12. The Savannah Orchid Tender
13. Scuzzy Q. Ridgeback
14. Omuru the Scowling Recluse
15. Clawface the Unbearable

Lanternbeak Jones

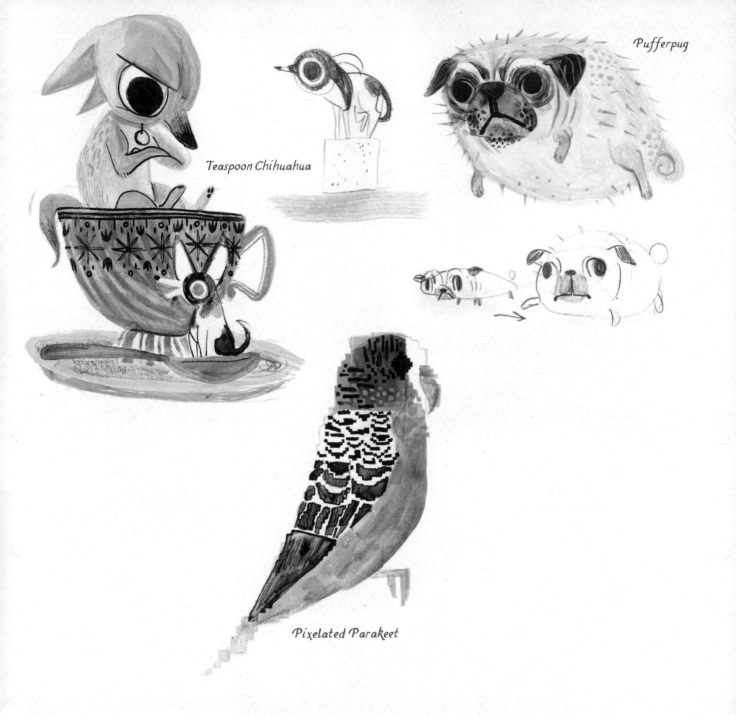

Pufferpug

Teaspoon Chihuahua

Pixelated Parakeet

Avant-Garde Pets

Meg Hunt

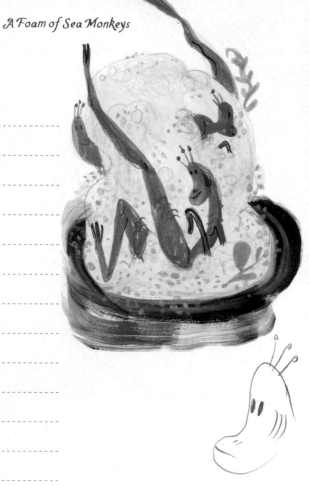

1. Teaspoon Chihuahua
2. Iridescent Sloth
3. Coffee Bees
4. Pufferpug
5. Sycophant Farm
6. Picasso Peacock
7. A Foam of Sea Monkeys
8. Quantum Goldfish
9. Lily-Tiger
10. Pixelated Parakeet
11.
12.
13.
14.

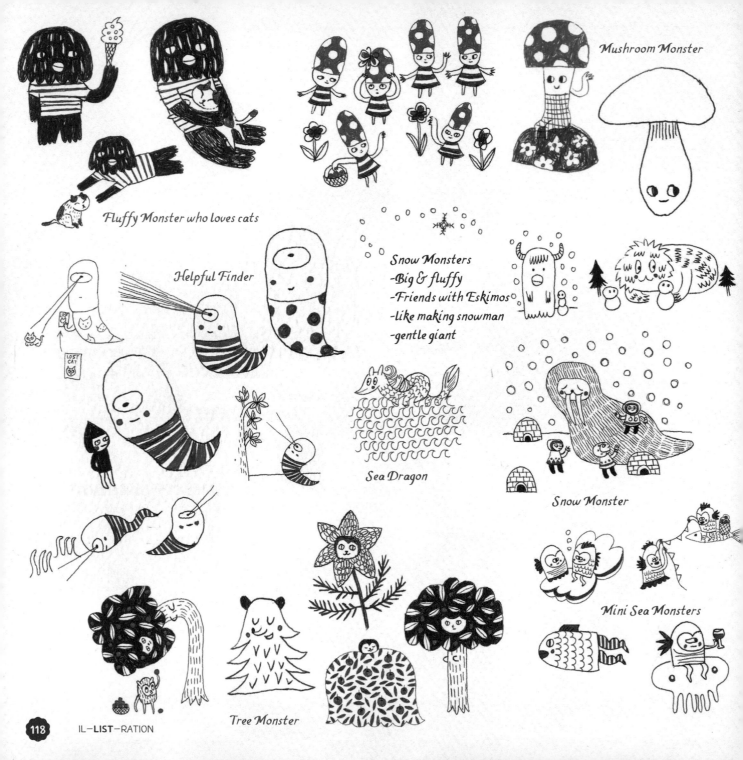

Fluffy Monster who loves cats

Mushroom Monster

Helpful Finder

Snow Monsters
-Big & fluffy
-Friends with Eskimos
-like making snowman
-gentle giant

Sea Dragon

Snow Monster

Mini Sea Monsters

Tree Monster

Gentle Monsters

Aya Kakeda

Flying Monster

Funny Monster

I started with my imagination to see what came up, and then I researched the theme. When I'm exploring a specific topic, I sometimes use the Internet. But when I'm working on more vague ideas where I have no concrete images in my head, I prefer going to the New York Image Library because there are always surprising findings and unexpected images to discover when looking through a variety of files and books.

Mermaid Monster

1. Fluffy Monster who loves cats
2. Mushroom Monster
3. Helpful Finder
4. Little Heads Monsters
5. Tree Monster
6. Gentle Monster with long hugging arms
7. Funny Monster
8. Flying Monster
9. Sea Dragon
10. Snow Monster
11. Mermaid Monster
12. Octopus Monster
13. Mini Sea Monsters

Little Heads Monsters

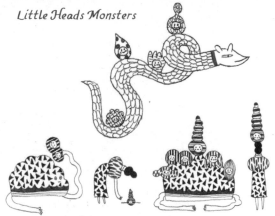

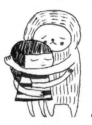
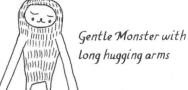

Gentle Monster with long hugging arms

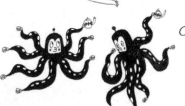

Octopus Monster

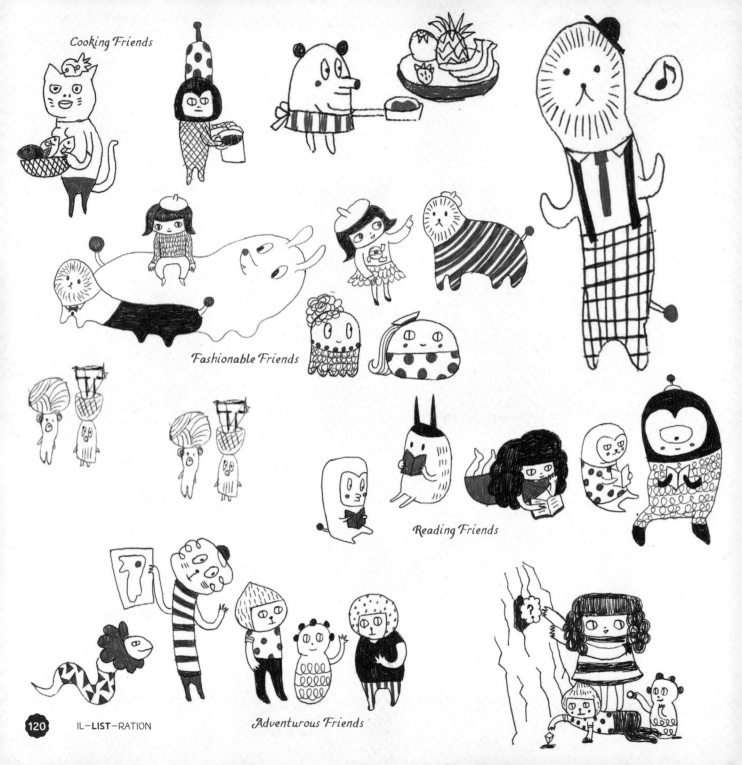

Cooking Friends

Fashionable Friends

Reading Friends

Adventurous Friends

Imaginary Friends

Aya Kakeda

1. Interesting Imaginary Friend
2. Reading Friends
3. Adventurous Friends
4. Exploring Friends
5. Fashionable Friends
6. Cooking Friends
7. Musical Friends
8. Flying Friend
9.
10.
11.
12.

Barry the Badger Bends a Broom

Barry the Badger Berates the Bereaved

Barry the Badger Blesses a Brick

Barry the Badger Burnishes a Balustrade

Barry the Badger Burdens a Bridesmaid

Barry the Badger Belittles a Baboon

Barry the Badger Burns a Barn

Barry the Badger Banishes a Beatnik

Barry the Badger Bifurcates a Bun

Books I Didn't Read as a Child

Roman Muradov

Best piece of advice for writing and illustrating your lists: Don't ask yourself why you're doing this.

1. Barry The Badger Bends a Broom
2. Barry The Badger Berates The Bereaved
3. Barry The Badger Burns a Barn
4. Barry The Badger Blesses a Brick
5. Barry The Badger Burnishes a Balustrade
6. Barry The Badger Banishes a Beatnik
7. Barry The Badger Burdens a Bridesmaid
8. Barry The Badger Bifurcates a Bun
9. Barry The Badger Belittles a Baboon
10. Barry The Badger Bores a Boozehound
11. Barry The Badger Brandishes a Brazier
12. Barry The Badger Bottles Bisexuality

Barry the Badger
Bores a Boozehound

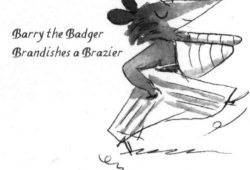

Barry the Badger
Brandishes a Brazier

*On incorporating creative exercises in his work, Roman says,
"I use constraints, OuLiPian and self-imposed, lots of reading
and research, even more walking around and thinking."*

Barry the Badger Bottles Bisexuality

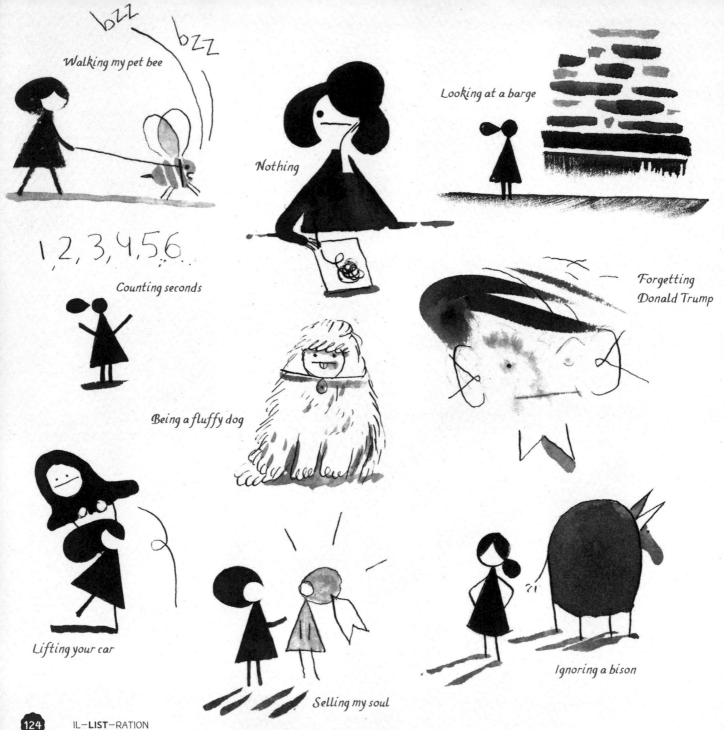

Walking my pet bee

Nothing

Looking at a barge

1, 2, 3, 4, 5, 6. .

Counting seconds

Forgetting
Donald Trump

Being a fluffy dog

Lifting your car

Selling my soul

Ignoring a bison

What I'd Rather Be Doing

Roman Muradov

1. Walking my pet bee
2. Nothing
3. Counting seconds
4. Being a fluffy dog
5. Forgetting Donald Trump
6. Lifting your car
7. Looking at a barge
8. Ignoring a bison
9. Discarding numbers
10. Selling my soul
11.
12.
13.

Discarding numbers

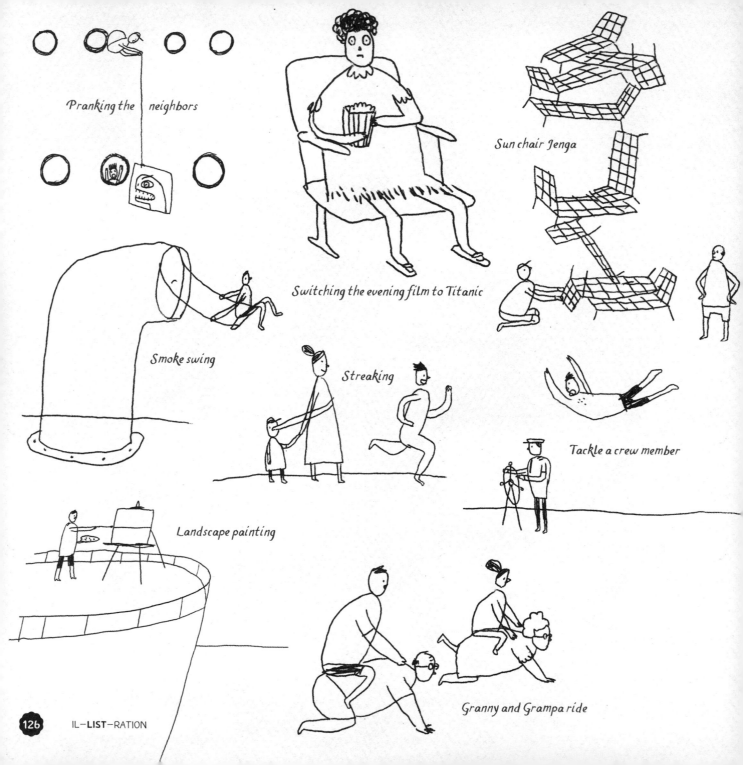

Pranking the neighbors

Switching the evening film to Titanic

Sun chair Jenga

Smoke swing

Streaking

Tackle a crew member

Landscape painting

Granny and Grampa ride

Cruise Ship Activities

Brian Rea

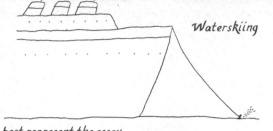
Waterskiing

When I'm working on an illustration, I try to select two or three key words that best represent the essay I'm working from. Once defined, I jot down more words or ideas that overlap with these key words. At first, I shake all the low-hanging fruit from the tree by getting all the overly ripe stuff (obvious ideas/words) down on paper. By getting these out of the way, I can see more clearly the directions that are more juicy and unexpected.

1. Landscape painting
2. Pranking the neighbors
3. Sun chair Jenga
4. Switching the evening film to Titanic
5. Tackle a crew member
6. Streaking
7. Drone battles
8. Waterskiing
9. Smoke swing
10. Granny and Grampa ride
11. Human shuffleboard

Drone battles

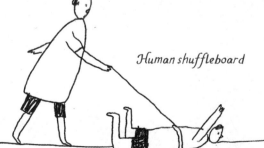
Human shuffleboard

Beard House

Head Gear

Solar System

The Tah Dah

First Place Facial Hair

Brian Rea

Kowabunga

1. Head Gear
2. Beard Mouse
3. Kowabunga
4. Solar System
5. The Tah Dah
6.
7.
8.
9.
10.

Once-loved prom dress
(appearing in photo album #6)

Coronation plate

Ornate teapot with
tea-stained interior

A very ugly patterned sweater

Mid-century modern lamp that
still works but might be really
ugly, depending on the room

Boy Scout shirt
with a few patches

The perfect jean jacket

Kitty figurine slightly
bleached from sunny days
in the windowsill

Great vintage
eyeglass
frames but 2x
magnification

Fake-distressed
classic Mickey
Mouse T-shirt

Beautiful 1950s dress
that says it's a size 8
but is obviously a 2

Never-used picture
frame with original
price sticker and
stock photo
still enclosed

Sombrero: an expensive
prop for Halloween
costume '02

Thrift Store Orphans

Julia Rothman

Fake designer bag

One night a week, I meet with a couple of other women at what we've come to call Ladies Drawing Night. I use these sessions to experiment with new materials, try out a new brush or pen or draw in a different style. These nights are also very social. Just talking about my drawings amongst peers helps so much. Using this relaxing environment helps me loosen up, experiment, and make art for myself, without a client's critique.

1. Sombrero: an expensive prop for Halloween costume '02
2. Loafers that gave too many blisters the first day wearing them
3. Once-loved prom dress (appearing in photo album #6)
4. Kitty figurine slightly bleached from sunny days in the windowsill
5. Coronation plate
6. "Men Are From Mars and Women Are From Venus" paperback
7. Lightly stained but pressed Burberry button-down
8. Wallet with business cards for cell phone company still inside
9. Fake designer bag
10. Fake-distressed classic Mickey Mouse T-shirt
11. The perfect jean jacket
12. Boy Scout shirt with a few patches
13. Ornate teapot with tea-stained interior
14. Never-used picture frame with original price sticker and stock photo still enclosed
15. Pink pumps
16. Faux leather jacket
17. Mid-century modern lamp that still works but might be really ugly, depending on the room
18. A very ugly patterned sweater
19. Great vintage eyeglass frames but 2x magnification
20. Beautiful 1950s dress that says it's a size 8 but is obviously a 2

Pink pumps

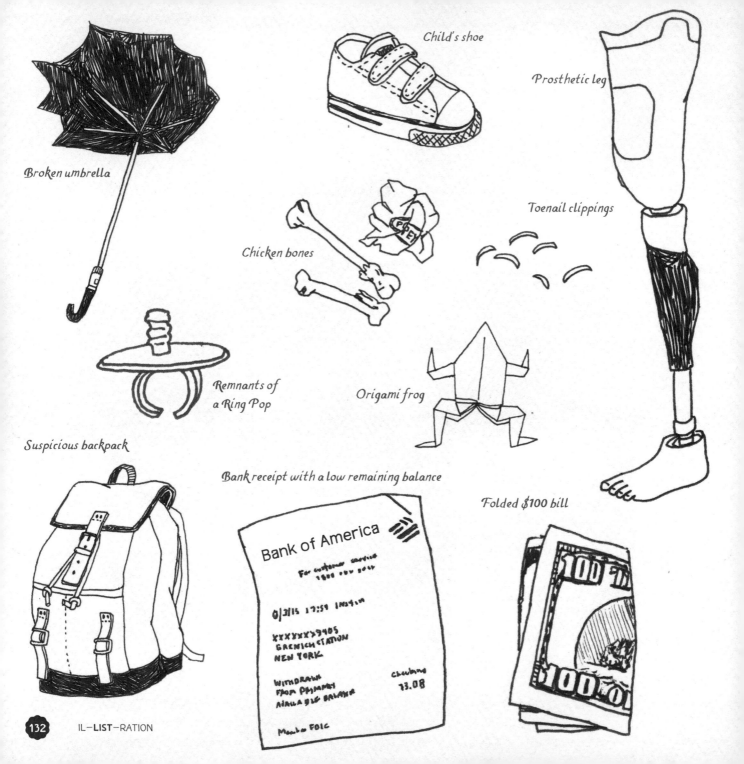

Broken umbrella

Child's shoe

Prosthetic leg

Chicken bones

Toenail clippings

Remnants of
a Ring Pop

Origami frog

Suspicious backpack

Bank receipt with a low remaining balance

Folded $100 bill

Found in the NYC Subway

Julia Rothman

1. Dentures
2. Broken umbrella
3. Unmailed love letter
4. Favorite sweater lost
5. Child's shoe
6. Bookmark with phone number written on it
7. Chicken bones
8. Toenail clippings
9. Empty rolling bottle that doesn't break
10. Broken boom box
11. Folded $100 bill
12. Prosthetic leg
13. Suspicious backpack
14. Remnants of a Ring Pop
15. Stained button-down that smells like beer
16. LED lightsaber
17. Broken sunglasses
19. Bouquet of flowers (dyed carnations—no note)
20. Bank receipt with a low remaining balance
21. Origami frog
22.
23.
24.
25.

Cubist Tea

Freckle Tea

White Trash Tea

Ogre Wart Tea

Old Crush Tea

Twins Tea

Sultry Sisters Tea

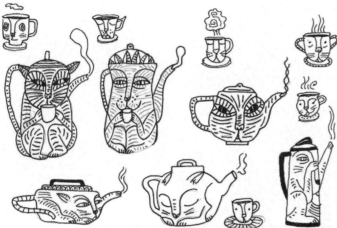

Kit-Tea

Criminali-Tea

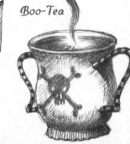

Boo-Tea

Inequali-Tea

Screaming Bloody Murder Tea

Special Delivery Tea

Lost Limb Tea

Uncommon Teas

Whitney Sherman

Don't be afraid to make images that don't exactly match your list. The best part of the idea may come out of the drawing process. The exercise should be about inspiration—it's not a matching game. For my list of teas, I thought of as many random, odd things as possible. I also tried playing with words that ended in "ty," which, in English, sounds the same as the word "tea," so the word curiosity becomes curiosi-tea, or kitty becomes kit-tea.

1. Cubist Tea
2. Freckle Tea
3. Lost Limb Tea
4. Ogre Wart Tea
5. Old Crush Tea
6. Twins Tea
7. White Trash Tea
8. Sultry Sisters Tea
9. Screaming Bloody Murder Tea
10. Special Delivery Tea
11. Curiosi-Tea
12. Kit-Tea
13. Inequali-Tea
14. Criminali-Tea
15. Atroci-Tea
16. Em-Tea
17. Boo-Tea

Atroci-Tea

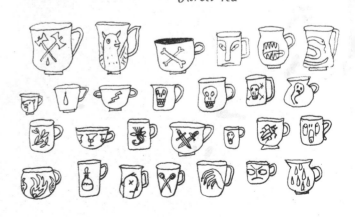

Em-Tea

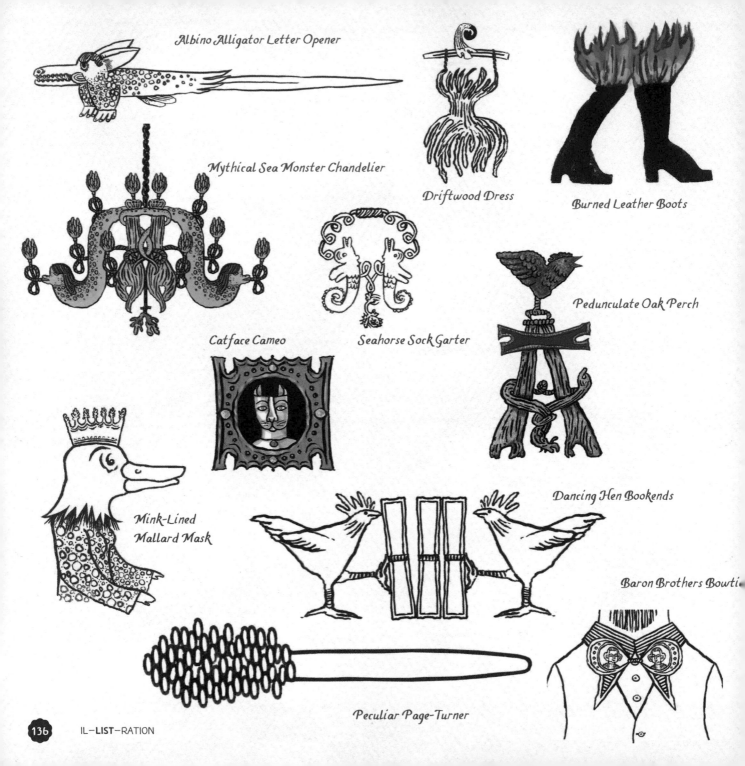

Albino Alligator Letter Opener

Mythical Sea Monster Chandelier

Driftwood Dress

Burned Leather Boots

Catface Cameo

Seahorse Sock Garter

Pedunculate Oak Perch

Mink-Lined
Mallard Mask

Dancing Hen Bookends

Baron Brothers Bowti

Peculiar Page-Turner

Forgotten Heirlooms

Cumulus Caplet

Whitney Sherman

1. Albino Alligator Letter Opener
2. Mink-Lined Mallard Mask
3. Mythical Sea Monster Chandelier
4. Handshake Roses
5. Burned Leather Boots
6. Driftwood Dress
7. Dancing Men Bookends
8. Seahorse Sock Garter
9. Baron Brothers Bowtie
10. Pedunculate Oak Perch
11. Cumulus Caplet
12. Peculiar Page-Turner
13. Curvilinear Candlestick
14. Ferrous Fire Tongs
15. Catface Cameo
16.
17.
18.
19.
20.

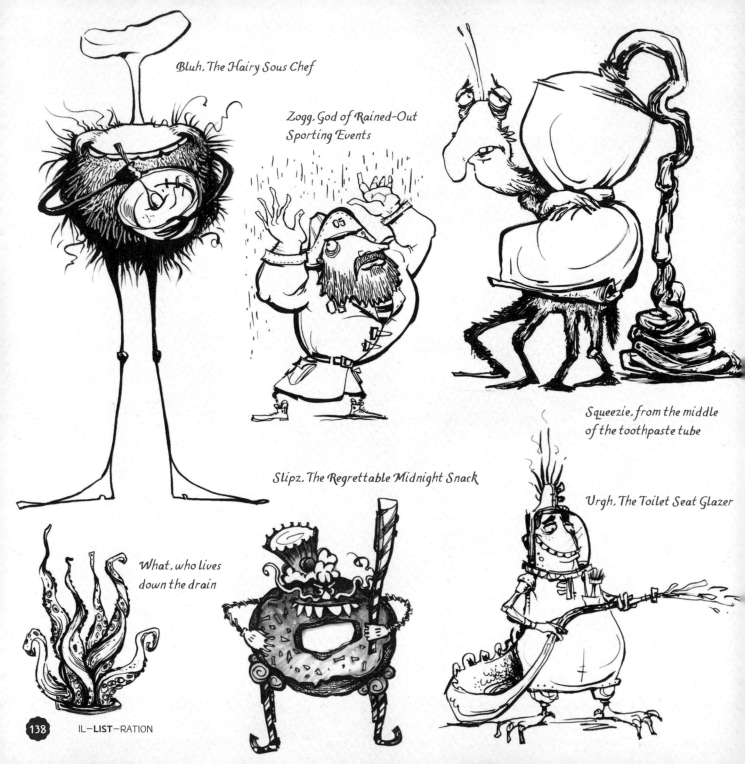

Bluh, The Hairy Sous Chef

Zogg, God of Rained-Out
Sporting Events

Squeezie, from the middle
of the toothpaste tube

Slipz, The Regrettable Midnight Snack

Urgh, The Toilet Seat Glazer

What, who lives
down the drain

IL-**LIST**-RATION

Imaginary Enemies

Wilson Swain

Yor and Migh Zippersdown

I love a problem to solve. I need a springboard to keep me motivated, interested, and playful. That is what is helpful about making lists—even just a list header. It's impossible to think outside the box if I haven't created a box first. For me, creativity needs parameters. There is nothing more intimidating than the blank piece of paper. Break the rules, but create some first.

1. Blub, The Hairy Sous Chef
2. D. Lacer, Untier of Shoes
3. Ghong! The Deadline Ringer
4. Louie The Heartbreaker
5. Slipz, The Regrettable Midnight Snack
6. Squeezie, From The Middle of The Toothpaste Tube
7. Urgh, The Toilet Seat Glazer
8. What, Who Lives Down The Drain
9. Yor and Migh Zippersdown
10. Zogg, God of Rained-Out Sporting Events

Ghong! The Deadline Ringer

Louie the Heartbreaker

D. Lacer, Untier of Shoes

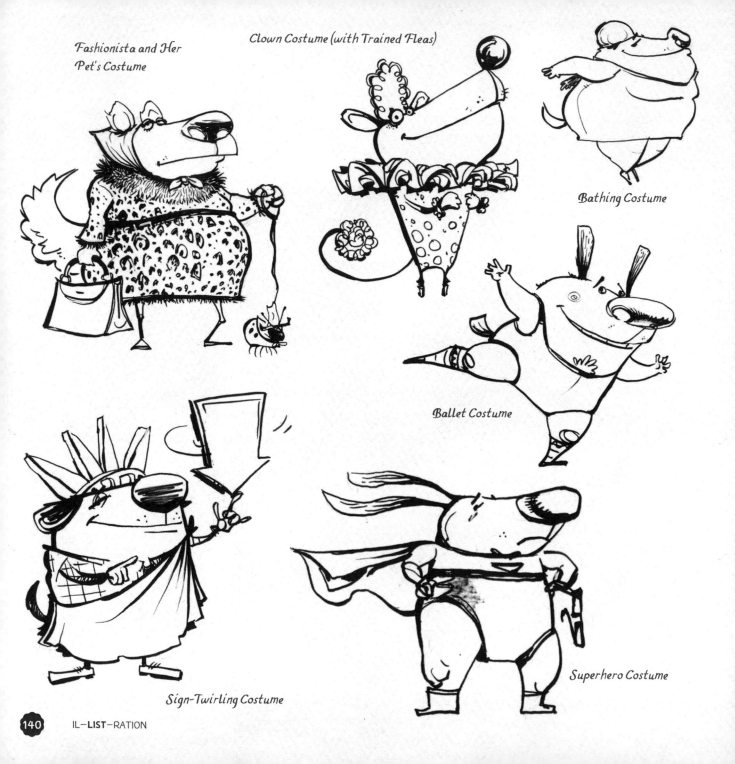

Fashionista and Her Pet's Costume

Clown Costume (with Trained Fleas)

Bathing Costume

Ballet Costume

Sign-Twirling Costume

Superhero Costume

Dogs in Costume

Wilson Swain

1. Ballet Costume
2. Bathing Costume
3. Clown Costume (With Trained Fleas)
4. Fashionista and Her Pet's Costume
5. Sign-Twirling Costume
6. Superhero Costume
7. Geisha's Traditional Costume
8.
9.
10.
11.
12.

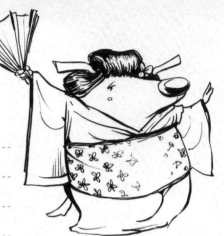

Geisha's Traditional Costume

NEXT

STEPS

WHAT'S NEXT
FOR YOUR
IL—LIST—RATIONS?

What Is Next for Your Il-LIST-rations?

Now that you have a wonderful new collection of ideas to explore, it is time to take your il-LIST-trated characters, places, and things and turn them into stories, pitches, and products. Try your hand at some of these suggestions for developing your doodles into dream projects.

CHARACTER IDEAS

Select a character from one of your lists. Play with this character in one or more of the following ways:

1. Write down as many facts about this character as you can. What is his middle name? Greatest fears? Favorite food? Secret weapon? There is a character profile worksheet for practice in the Appendix of this book.

2. Draw five new versions of your character. Try to make these representations very different from your first while maintaining the overall concept and core of your creature. Choose your favorite. Then draw this character's best friend and his biggest rival.

3. Write out an everyday scenario involving your character. What would your character buy at the grocery store? What books would he check out at the library? Now do the same with extraordinary scenarios and see how you your character behaves. What would your character do if faced with an impending apocalypse, or if he becomes the eyewitness in a crime scene?

4. Draw five different outfits that your character would pick out (if your character wears clothes). Consider clothes for work, play, fancy occasions, and for when no one is watching. Add accessories.

5. Curate a life as your character. Use Pinterest.com (or a web search and a character folder on your computer) to collect images from your character's point of view. Where does it live, what does it read, eat, wear, and believe? What motivational saying does it inundate its followers with on social media or the equivalent?

SPECIFIC PLACE IDEAS

Select a place or setting from one of your lists. Try pinning down your dreamed-up destinations by trying a handful of these exercises:

1. Answer the five W's in terms of your place. Who lives there? What happens here? Where is this place? When is/was this place? Why does this place exist? These questions can help hash out the basics of your location.

2. Draw a map of your place. If you are designing a city, draw the city center and surrounding areas. If you are imagining a character's clubhouse, draw out its floor plan and the area surrounding it. This grounds your place within a larger world.

3. What is the history of your place? Did the house/building/land/city once belong to someone else? Is there a conflict or relationship relevant to this history?

4. Are there rules in your place? Write ten rules adhered to by those who inhabit it. These can be in the form of official decree or casual guidelines. When and why were these rules established?

5. Go to a space that is in the same category as your imagined one. If your space is a suburban neighborhood, find one to explore. If your space is a tourist trap, find one to take in. If you are building an epic historic city, you may research one. Make a list of at least fifty things you see and find there, and use them to imagine how those things are similar and different in your setting.

SPECIFIC OBJECT IDEAS

Choose an object from one of your lists. Find a larger story in your curious objects by tackling a few of the following drills (all drills may not work for all objects):

1. Does your thing belong to someone or something? If not, is it seeking an owner? Draw a picture of the character who you imagine owns it or who you think might own it one day.

2. If you do not have a clear idea to whom your object belongs, think about who might benefit from it. Make a list of likely candidates. Then make a list of unlikely candidates. Imagine ways in which the unlikely ones came to own your thing. Pick your favorite character and complete 1 above.

3. Draw five new examples of your object. See how different you can make it look while still keeping the overall concept and essence of the thing intact. Play with color, scale, texture and shape. If the object is functional, could it serve a dual purpose? What might that purpose be?

4. Pretend that you have just dug up your object at an archaeological site. How would you describe it if you had no knowledge of its function? Write down its exact measurements, color, texture, location found, and describe five hypothesized uses based on its physical appearance.

5. Try anthropomorphizing your object. Give it a personality. Now that your object is a character, you may try some of the character exercises with it to see where it might go.

Improvisational Insight for Creativity and Life

I hope you've enjoyed making lists and drawing some new and exciting (and strange and silly) imagery. I hope you've found some ideas that you will delve into even further to create bigger projects. Hopefully this book has brought you joy, energy, and a renewed interest in pursuing more playful problem solving. Learning to surprise yourself and break your natural habits is good for kick-starting innovative ideas.

This book has focused on one specific exercise, but creatives (and anyone else) can discover many lessons for creativity and life from the principles of improvisational acting. Comedic and theatrical actor and improv instructor **KEITH REAY** offers some advice that is as effective in your sketchbook as it is onstage, and describes some additional exercises and games.

QUICK RULES FOR IMPROVISORS AND CREATIVES ALIKE

- ~ Slow down and shut up. (We're not quick on our feet, we're in the moment.)
- ~ Believe what you're doing. (If you don't, you can't expect your audience to believe it.)
- ~ Have an emotional connection to your work.
- ~ Live a fuller life offstage and tell us about it onstage.
- ~ Play your parents, your neighbor, or your accountant. (See through their eyes.)
- ~ Listen with more than just your ears.
- ~ You already know everything you need to begin.
- ~ Fake it 'til you make it. (I know you have a losing poker hand by the face you made.)
- ~ Don't focus on yesterday or tomorrow, you can only work in the now.
- ~ When you're in your head, more thinking won't fix things.
- ~ It's called "going to see a 'play'" for a reason.
- ~ Leave your audience thinking, "How'd they do that?" not "I could do that."

1. **Third Choice or A to C thinking.** (This is one of my favorite thought experiments.)
 Imagine that I have two nonperformers on a stage and I ask them to improvise a scene based on the suggestion of "baseball." Statistically, what do you think they will do?

 FIRST CHOICES (A THINKING)
 They will probably
 - ~ start playing baseball
 - ~ play catch with each other
 - ~ be at a baseball game
 - ~ be watching a baseball game on television
 - ~ be listening to a baseball game on the radio
 - ~ be trading baseball cards with each other

 SECOND CHOICES (B THINKING)
 They might
 - ~ be listening to a baseball game while driving a car
 - ~ pretend they're baseball players and are signing autographs
 - ~ be getting the dugout ready for the game as the bat boy
 - ~ be cutting the grass as the groundskeeper
 - ~ be purchasing new equipment at a store

 THIRD CHOICES (C THINKING)
 They could
 - ~ be decorating a cake for a baseball-themed birthday party
 - ~ be searching online for a signed Nolan Ryan baseball for dad for Father's Day
 - ~ be tearing down homes so a stadium can be built

The idea of third choices is to avoid the predictable. We want to avoid making the same surface-level decisions that everyone tends to make. When you get a suggestion, take a moment or two and think to yourself, What's the predictable choice? Then do something far away from that. If you are assigned "Starbucks," for example, avoid coffee, drinking coffee, buying coffee, being caffeinated, studying anything that brings up an immediate pattern as to how you arrived at the story we're watching. Don't settle for the obvious. You don't want your audience to think, "I see you just get a suggestion and act it out. I can do that, that's simple." Instead, take us on a journey. If, for example, you start building a fire at a campsite and say, "I'm glad I took this weekend off from serving coffee so I can just relax in the wilderness," the audience will want to see what you do next. If you start by saying, "I'd like a decaf Pike with room," we can only watch you purchase it, put cream in it, drink it, and start talking about how good it is.

How this translates to illustration: When you have a visual problem to solve, think about how you can solve it without resorting to an A choice. Can you anticipate what viewers would expect to see and then use that to take them somewhere new? Can you deliver a C choice and make the viewer feel satisfied by the leap?

2. **No Negativity.** This may be self-explanatory but it is a necessary reminder. Negativity is the killer of all creation. It's the easiest choice to make and I see it all day onstage when I'm teaching improv. In creative endeavors, the cynic, the downer, the hater—these characters do not work unless they're over the top.

 Offstage, it is good practice to take what has been given to you and add to it to see what you can create. In collaborative environments, this can amount to a solution that is much greater than its parts! Alone, this practice can allow your most daring and silly ideas (and sometimes your best) to see the light before they are squashed with doubt.

3. **Fire the Judge.** There's a little judge who sits on your shoulder and whispers into your ear constantly, saying things like, "That's a stupid idea" or "She's prettier than you" or "Your parents are right, you should do something else with your life." This list is ongoing. The judge showed up one day in your early childhood and planted the seed of doubt and every time you let him win, that seed grows. Fire the judge! Take notice when the judge returns to the post and tries to win again. You have to be stronger than the judge. Remember: *You* elected this judge, and *you* have the power to fire him.

4. **Collaborate.** Find a group of friends (they don't have to be artists) who you can reach out to for inspiration. They can act outside of your brain and give you ideas that you weren't already thinking about. In improvisation, we get suggestions for a couple of reasons: sometimes using suggestions prove that what we are doing onstage isn't scripted. Oftentimes it's because we want to perform something that none of the players currently have on their minds. Try texting a friend: "Give me a noun" or "What's something that makes you cringe" or "Give me a six-letter word beginning with L." Suggestion generation can be fun in its own right.

5. **Practice inventing stories for strangers.** Choose a stranger you spy in the grocery store (or anywhere you like). Based on his or her physical appearance, presence, and demeanor, begin writing what you believe is that person's story. Specificity is key. Focus on what is special about him or her.

 FOR EXAMPLE:

 The older woman picking out a ripe apple in the produce section: Give her a name: (Let's call her Darcy).

 What's her story/Who is she?/What's special about her?

 "She gives great Christmas presents." "She has four children: three boys and, finally, the girl she's always wanted." "The grass stain on her dress is from replacing her neighbor's tulip bed after her golden retriever got into it."

 The young guy purchasing three potatoes, celery, and box wine at the checkout: (Let's call him Robert because he looks like one.)

 "He's trying to impress a girl he likes by cooking for her." "He's the friend you call if you need a lift to the airport." "He's really into basketball—he knows all of the statistics of his favorite team."

 Make your specifics colorful and fun.

 Now try writing a list as one of these characters. Or take a character you've drawn but know little about and start a similar mythology.

6. **Try taking an improv class.** No experience is necessary. Your brain will get a productive, creative workout, and you will embody new characters and unique ideas worth exploring.

Creating a Memorable Character

Copy this sheet and answer the questions for each character you develop. Be sure to fill in every space because those that are difficult to fill often reveal the most interesting details. Not all of these answers will appear in your final work, but will add to your understanding of the character and add depth to your project. Think of additional questions that could also be revealing.

Character's name (include middle and last name, if applicable) _____

Birthday and age _____

Best friend _____

Worst enemy _____

Places he/she has been _____

Things he/she has done _____

Things he/she likes to do _____

Favorite music _____

Does your character like to read? What does he/she read? _____

Biggest fears _____

Things your character hopes to accomplish _____

What is your character's hidden talent? _____

Favorite food? _____

What is your character's currency? What motivates him/her/it? _____

Your character's most treasured possession _____

Your character's deepest secret _____

Generate Your Own Lists

Why not continue your lists even after this book is complete? Use this worksheet to come up with new list titles over and over. Draw a line from any A-column word to any B-column word. You can make your list from these two columns or choose to add a phrase from column C. Try random combinations to develop list titles you'd never have conceived on your own.

A	B	C
Scientific	Desserts	In Outer Space
Fancy	Symbols	For Ghosts
Pink	Holidays	At Wizard School
Forgotten	Projects	For Cats
Bold	Traditions	For Sailors
Renegade	Exhibits	In Prison
Long-lost	Pizzas	In Manhattan
Ambitious	Prime Ministers	For Country Folks
Exciting	Gadgets	For Hipsters
Unpopular	Mascots	For Parents
Golden	Islands	In an Office Cubicle
Literary	To-Dos	From Eastern Europe
Contemporary	Board Games	In the Circus
Surprising	Musicals	For Unruly Children
Eclectic	Tchotchkes	Found at the Beach
Epic	Museums	At a School Dance
Cool	Names	For the Elderly
Fantasy	Battles	At Daycare
New	Parades	In the Land of Make Believe
Ancient	Societies	For Believers
Extreme	Crafts	In the Amazon
Terrifying	Creatures	At the Mall
Rare	Tattoos	To Write Home About
Loud	Fashion	On the Internet
Alternative	Treasures	From the 80s

RESOURCES

Hopefully this book has generated new possibilities for your work. In an entrepreneurial marketplace, you can choose to make your own products and projects for yourself, friends, or to sell to others at events or on the web. Here are a few quality resources for executing your creative projects.

CUSTOM DIGITAL PRINTING

www.blurb.com (books)
www.lulu.com (books)
www.smartpress.com (books and more)
fireballprinting.com (large format books and more)
pinballpublishing.com (scout books and more)
www.moo.com (cards and more)
www.overnightprints.com
www.newspaperclub.com (newspaper, UK)
www.whiteduckscreenprint.co.uk (screenprinting on paper and fabric, UK)
www.ripedigital.co.uk
www.emtone.co.uk (digital litho printing, UK)

CUSTOM PRINTED FABRIC

www.spoonflower.com/welcome
www.dpi-sf.com (also prints and finishes pillows and scarves)
www.rasmart.co.uk (fabric printing, UK)

SCREENPRINTING

www.vgkids.com (screenprinting on paper and fabric)
www.heraldicpottery.co.uk (screenprinting on ceramic and glassware, UK)

CUSTOM PRINTED AND LASER—CUT CHARMS

www.inkitlabs.com

3D PRODUCTS AND PROTOTYPING

www.shapeways.com
www.ponoko.com

ILLUSTRATED PRINTS AND/OR PRODUCTS CREATED AND SENT DIRECTLY TO BUYERS

http://society6.com
www.inprnt.com

CUSTOM—PRINT CLOTHING

https://paom.com

CROWDFUNDING

www.kickstarter.com
www.indiegogo.com
www.patreon.com

CUSTOM WALLPAPER

www.surfaceprint.com (wallpaper, UK)

CONTRIBUTOR BIOS

JULIANNA BRION starts her day playing around in her sketchbook with her cat Ghostface by her side. She creates imaginative imagery for all kinds of clients and gallery walls and has earned recognition from *American Illustration, 3x3*, the Society of Children's Book Writers and Illustrators, and a silver medal from the Society of Illustrators in NYC. JuliannaBrion.com

CALEF BROWN can often be found letting his mind and pen or pencil wander and playing with words to go with the images. His award-winning (and *New York Times* best-selling) picture books showcase the magnificent potential of text and image and his doodle book *Dragon, Robot, Gatorbunny* shares his love of drawing with kids (and their parents, too). CalefBrown.com

MIKEY BURTON wakes up to lots of coffee and always picks up an old-fashioned pencil before he starts pushing pixels. He is a designy illustrator and champion problem solver who draws text and imagery for innovative brands big and small. Mikey has worked with clients including Converse, ESPN, Target, the *New York Times*, and Kaiju! Beer. MikeyBurton.com

JOHN HENDRIX believes that our society drastically undervalues the importance of goofing off. He takes his sketchbook with him everywhere and encourages others how and why to do the same in his take-along title, *Drawing Is Magic*. John writes and illustrates books, solves conceptual visual problems for major clients, and teaches up-and-coming visual communicators at Washington University in St. Louis. JohnHendrix.com

MEG HUNT is a tireless seeker of illustrative products and forms. She has stitched pendants, sewn ornaments, felted friends, etched pint glasses, designed jewelry, painted on purses, resurrected rubylith, and printed on paper and fabric in the name of illustration. Meg also teaches new talent at Pacific Northwest College of Art and works for major clients and gallery spaces. MegHunt.com

AYA KAKEDA is a playful experimenter and accomplished creative collaborator. Her illustrative work has taken on a myriad of innovative purposes and forms. Aya's characters have been made into vinyl toys and have been stitched onto exquisitely elaborate quilts. Her paintings have been displayed and sold in galleries all over the world and printed in numerous books and magazines. Aya also shares her talents with the younger set through museum workshops for kids. AyaKakeda.com

ROMAN MURADOV embraces the practices of *Oulipo*, which (much like an improv game) recognizes the power of constraints in creating work. Roman is an illustrator and cartoonist whose clients include the *New Yorker*, the *New York Times*, *Vogue*, and *Lucky Peach*. He's won many awards, including a gold medal from Society of Illustrators, and has been self-publishing his romanthology called the *Yellow Zine* over the past decade.

BRIAN REA makes lists whenever he starts solving a visual problem. He has led workshops in the making of ambitious murals using black tape and has covered big walls himself in Milan, Barcelona, and Los Angeles. He has worked with fashion houses and animators and has produced drawings and designs for books, murals, fashion, posters, music videos, and magazines around the world. BrianRea.com

KEITH REAY teaches improvisation at the world-famous Second City in Los Angeles and embraces the power of saying yes. He began his professional acting career right out of high school with Second City in Detroit. At seventeen, he was the youngest person in history to be hired for their touring company, and has steadily been a part of inspired theatrical and commercial projects ever since.

JULIA ROTHMAN is a playful and prolific illustrator with notable clients who has also embraced entrepreneurship and pitched and produced ambitious and successful personal projects. Julia's work can be seen on fabric, bedding, wallpaper, cards, teapots, dinnerware, and in ad campaigns and illustrated books. Some of her clients include Chronicle Books, Target, Anthropologie, Crate & Barrel, Urban Outfitters, the Land of Nod, and Victoria's Secret. JuliaRothman.com

WHITNEY SHERMAN is an illustrator, educator, and entrepreneur who embraces the challenges of change by practicing and teaching beyond the conventions of traditional illustration. Whitney creates illustrated tableware, linens, pillows, and products for her own Pbody Dsign as well as working with major clients. Whitney is director of the MFA program in Illustration Practice at Maryland Institute College of Art, an experimental program and playground for the future of Illustration. WhitneySherman.com

WILSON SWAIN has experimented with his own world of characters in pencil, ink, paint, sculpture, and digital techniques. His sometimes dark and always playful whimsical work finds inspiration in old books, toys, and second-hand shops. His client list includes the *New York Times*, Simon & Schuster, Houghton Mifflin, and Chronicle Books. He has illustrated a number of books for readers young and old including *The Castaway Pirates*, *A Nutty Nutcracker Christmas*, and *The Castle of Shadows*. WilsonSwain.com

ACKNOWLEDGMENTS

Thanks to Eric for being my husband and favorite friend and for listening patiently to and supporting my crazy ideas without asking why. And thanks to mom and dad for always encouraging art and play.

Thanks to Whitney Sherman for giving me my first teaching opportunity and to all of my brilliant former students for taking risks and proving that experimentation and play leads to unexpected and wonderful things.

And many thanks to Jonathan Simcosky for the idea to make this book and for seeing me through the process.

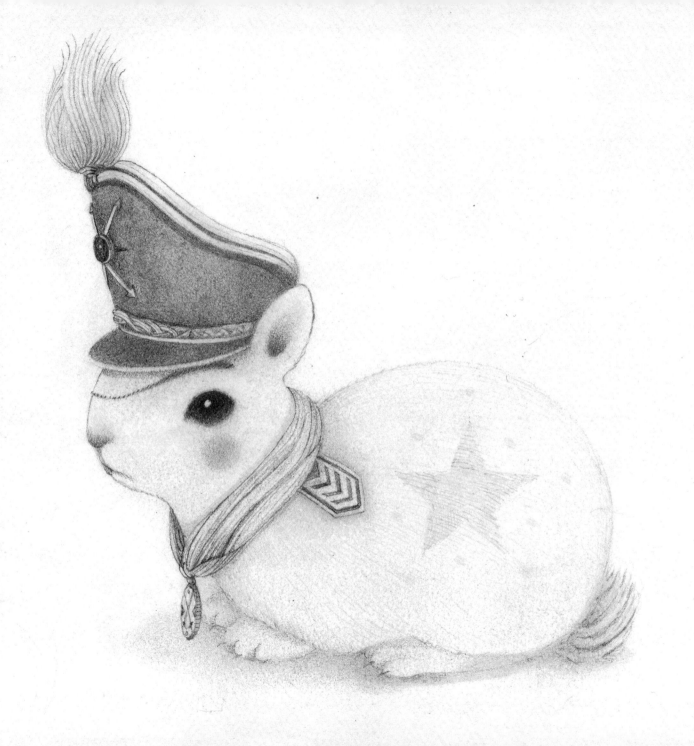

ABOUT THE AUTHOR

JAIME ZOLLARS has illustrated children's books, magazines, newspapers, and ad campaigns. Her clients include United Airlines, Random House, the American Red Cross, Simon & Schuster, Scholastic, Clarion Books, Quarry Books, and the *L.A. Weekly*. She has also created artwork for galleries including Copro Nason, Gallery Nucleus, and Giant Robot.

Jaime's art has been recognized by a bunch of great publications and societies, including Taschen's *Illustration Now!*, *American Illustration*, *Communication Arts*, Society of Illustrators, *3x3*, Spectrum, *Curvy Australia*, *Design Taxi*, XFuns Taipei, DPI Taiwan, BBC's *Culture Shock*, *Small Magazine*, *Creative Quarterly*, the SI-LA, and the SCBWI.

Jaime happily lives and works in Charleston, South Carolina, with her dashing husband, sarcastic eight-year-old boy, and sunny three-year-old girl. While in Baltimore, Jaime was lucky enough to teach up-and-coming art superstars in both the MFA and undergraduate illustration programs at the Maryland Institute College of Art (MICA). Jaime has also served on several boards, including the Los Angeles SCBWI, the Society of Illustrators of Los Angeles, and the Illustration Conference (ICON).

Jaime is inspired by fairy tales and Flemish painters, nonfiction books, forgotten paper, found textures, and flea market photographs. When she isn't painting for commercial clients or gallery walls, you'll probably find her eating eclairs, taking an improv class, reading up on North Korea, making mechanical paper toys, eating more eclairs, or driving her children to and from all of those activities she said she'd never drive her kids to and from.

ALSO AVAILABLE

100 Things to Draw with a Triangle
ISBN 978-1-63159-100-6

Cloud Sketching
ISBN 978-1-63159-095-5

*20 Ways to Draw a Doodle
and 44 Other Zigzags, Twirls,
Spirals, and Teardrops*
ISBN 978-1-59253-924-6